The Internet Design Project
The Best of Graphic Art on the Web

Universe

search and text: Liz Faber
fab@centaur.co.uk
roduction/conclusion: Patrick Burgoyne
trickb@centaur.co.uk
nsultant Editor: Lewis Blackwell
visb@centaur.co.uk
sign: Adrian Talbot, Intro, London
ww.introactive.co.uk

First published in the United States in 1998 by
UNIVERSE PUBLISHING
A Division of Rizzoli International Publications, Inc.
300 Park Avenue South
New York, NY 10010

This book was created by Calmann & King Ltd in
association with Creative Review

Distributed to the U.S. trade by St. Martin's Press, New York
Distributed in Canada by McClelland and Stewart

Library of Congress Catalog Card Number: 97-61796

ISBN 0-7893-0124-5

Printed in Italy

Start up the software and embark on a new journey: where do you want to go today?

It is no accident that the two most popular web browsers, Netscape Navigator and Microsoft Explorer, both employ metaphors of discovery in their names. Out there are millions of sites touting for business, each imploring 'Stop. Look at me. Don't be in such a hurry, come and spend a little time here.' Even those hammering down the information superhighway with a definite destination in mind are easily seduced into a detour by these cyber sirens.

Each voyage is a new experience, a search for a few precious moments of diversion, of entertainment, of enlightenment.

This book is a taste of what is out there, why it is there and how it got here. The Internet Design Project launched a global search to find the websites that are at the forefront of the digital revolution. We invited over 100 creative web professionals worldwide, each of whom is playing a leading role in building this future in cyberspace, to nominate the sites which they felt represented the pinnacle of achievement in the medium from a design perspective.

Their recommendations have been boiled down and filtered to provide the best of the best of websites. In reviewing and analysing each site, we checked in with its creator to discover its purpose and the thinking behind it.

What is obvious from the results is that the future of the web is up for grabs. Whether it ends up resembling television, magazines, theme parks or a whole new medium of our own invention, the industry is agreed that the most important factor in the web's success will be the provision of stimulating content. Publishing technology guru Jonathan Seybold has stated that: 'The web is in transition from when this was techie stuff to a situation where serious content people and decent design will take over.' And that is where the creative industries come in.

The web has already had a huge impact on the design and advertising industries. Website production has proved to be a highly lucrative and controversial new market. Virtually every advertising agency has a new media department. Hundreds of new design start-ups claim to offer confused clients a complete cyber solution.

A gold rush mentality has pervaded the scene. Certain unscrupulous firms have charged way over the odds for their services to clients ignorant of the true costs involved, yet desperate not to be the last among their competitors to go online. This, in turn, has provoked a backlash among clients uncertain of the true commercial value of the web.

Within the creative industries themselves the web has spawned changes in the way that designers and advertising creatives work and think which will have lasting significance. The desktop publishing revolution encouraged designers towards isolation. With the coming of PostScript they no longer needed the specialist skills of typesetters. Pages could be laid out on the computer screen. Artwork could be scanned in on the desktop and images manipulated and retouched. Even a large amount of mundane illustration work such as tables, boxes and icons could be done by designers themselves.

But producing web pages requires team work. Designers must return to working with specialists. Netscape co-founder and senior vice-president (he's in his mid-twenties) Marc Andreessen predicts that 'teams composed of graphic designers, information designers and software developers will be the norm'. Engineers, musicians, animators, filmmakers, writers, poets and photographers can all find a role. One such collaboration has resulted in two of the best sites on the web – that for Ruskin School of Drawing and Fine Art (www.ruskin-sch.ox.ac.uk) and The Cooker (www.ruskin-sch.ox.ac.uk/cooker). The guiding creative light behind both was British multimedia artist Jake Tilson. While artist-in-residence at the Ruskin, Tilson began working with an Oxford-based company named True-D Software to produce the websites. These 'hardcore programmers', as Tilson calls them, worked together with him in what he terms 'a very good art/science cooperation, equally beneficial to both parties'.

Tilson believes that designers need to understand the technical aspects of the web in order to get the best out of it. 'I've had arguments with designers who don't feel that they have to be able to write HTML [Hyper Text Mark-up Language] in order to be able to design an internet site,' he has said. 'I completely disagree. I think you have to be able to program to be able to design for the internet as well as being able to write HTML.' Tilson's argument is that if designers understand the programming tricks that save download times and generally make a site work better, life will be far more pleasant for the user.

His case becomes stronger when one realizes that, unlike print or television, not everyone is looking at a website with the same pair of eyes. Few computers are set up the same. Different hardware specifications, different browsers, different plug-ins to play video or audio or animations are all variables to be taken into consideration. If the appeal of your site hangs on some really cool piece of animation, half the world may never see it. In the worst case scenario, some users instruct their browser not to show any pictures at all which makes graphics-based pages virtually unintelligible and the designer's role redundant.

Part of the problem stems from the fact that the internet was originally set up as a means of transporting text-based documents containing scientific data – layout, except in a very basic sense, was not deemed to be an important factor. Everything about HTML was done to make the transfer of information as quick and easy as possible. Then, in 1992, Mosaic was invented, the first browser capable of displaying graphics on the web, and the whole game changed. Suddenly the web could be used for entertainment, not just information. The introduction of Netscape Navigator in 1995 pushed browsers further down the graphic route. Each new version gave designers more and more control over layout and yet moved further away from the pure, unadulterated concept of HTML.

But despite these improvements, compared to print, the web is still a low-resolution aesthetic. Designers have had to change the way they think about using images when working on the web. The impact of finely printed photographs or great cinematography is nullified when viewed in tiny windows on computer screens. Despite improvements in the compression of the large files that images or video need, resulting in less time spent waiting for them to appear, quality remains poor. Given the restrictions, should designers just forget about graphics?

'In my work I've always had to rely on a lot of two-colour printing. I think it takes a level of ingenuity to get a good design out of two-colour printing and in the same way it takes a level of ingenuity to get the best out of HTML,' Tilson has claimed. 'People are missing the hidden power of HTML if they start throwing lots of graphics into it and ignore what

you can do with just the basic specifications. Background colour, frames, type – all of those things can be used creatively and cleverly.'

Some designers may be surprised to hear Tilson claim that type can be used creatively on the web. For many typographers the web represents anathema. When HTML was created it only allowed for the use of two typefaces (and why bother with anything else when the web was only going to be used to publish scientific data?). Most browsers have defaults set to display text as 12-point Times with 12-point Courier as an alternative. The only way for a designer to introduce other fonts is for them to make them part of a graphic. Also, HTML only supports basic characters – 26 upper- and lower-case letters plus basic punctuation. There are no smart quotes and no 'em' spaces. This requires new thinking about the use of type in a layout, both in terms of the number of faces that can be used and the way that they are used to convey information.

But these restrictions also raise an intriguing new opportunity. The browser's type defaults can be changed. It is up to the user to choose whichever font they like. Thus, the relationship between designer and consumer becomes utterly different to that in any other medium. A designer might hate Chicago with a passion but if the consumer likes it, then that is the typeface that the site will be displayed in. The designer no longer has total control over how his or her work is presented.

And it is not just designers who are having to rethink their methods on the web. Advertising is struggling to find a model that works. Finely crafted commercials are either ignored because no-one can be bothered to wait for them to download or are destroyed by poor playback quality. And in the flashing, blinking, spinning world of the web, posters transplanted from print can look pedestrian and dull.

The industry's first attempt to innovate involved banners – digital posters placed on host sites. Early internet users declared them ineffective and determined to ignore them but advertisers persisted to the extent that later research suggests that banners can be a very useful tool in attracting passing traffic. Next came a wave of brand-based homepages that shows no sign of relenting: there are currently thousands of brands thus represented on the web. Unlike the captive, couchbound audience for television commercials, it takes real effort for a consumer to visit your site – so it had better be worthwhile when they get there or they will not come visiting again. It is common for consumers to praise television commercials by saying that they are better than the programmes. The advertising industry has learned that it needs to elicit the same kind of response to web pages. Perhaps the most encouraging thing about these sites for the advertising industry is that they allow creative staff to return to the roots of advertising – talking about the product and what it can do for

you without relying heavily on craft techniques except of course that producing a good website is, in itself, a craft area).

A well-thought-out brand-based website can be an excellent marketing tool, but what else really works on the web? Erik Lundberg, director of sales and interactive marketing at Total Entertainment Network, one of the most successful sites around, has cited search engines and directories as having the best chance of success. He also includes content providers who have an existing presence elsewhere, such as television stations or magazines.

But despite the fact that many magazines have set up a presence on the web, the majority struggle to make any real money. Many early ventures lost large amounts of cash. Perhaps part of the problem is a clash of cultures between the exclusivity of information, which is such a driving force for magazines to attract readers, and the web's ethos of sharing. Many argue that the print metaphor itself is unsuitable for the web and yet much of the web's visual language comes from print.

Open up the browser on your desktop and you tend to be presented with an A4 window. Why does the interface for a digital medium deem it necessary to replicate the size and shape of a piece of paper? Because everything on the computer desktop is geared towards print – whether it be via a LaserWriter or a press. But the web exists in cyberspace, that is its final destination. Unlike page layout programmes or PhotoShop, the end product is not output, it stays within the computer.

Looking at many web pages, however, one would be forgiven for not realizing that. The linear print model of a contents page, then shorter, news-type pieces followed by longer features is surprisingly common. Yet the web is a non-linear medium. Its great strength is that people can jump from site to site via hyperlinks. They do not always arrive conveniently at the beginning. A user entering a strictly hierarchical site somewhere in the middle may not have a clue as to what is going on. (It should be noted that frames technology, where a browser window can be divided into separate areas each holding a different HTML file, has made strides towards addressing this problem by allowing orientating icons to be constantly displayed down one side of a site.)

Following a print model also leads to a problem which is largely ignored by cheerleaders for what is an American-dominated medium. Print-based tends to mean text-based which limits communication in what is supposed to be a medium for building communities across geographic boundaries. The web is only world-wide if you speak English.

The web's detractors like to point out that it will never achieve the stability, portability and tactile pleasure of a book, so why even go down that road when the result is simply to invite unfavourable comparisons? At first, perhaps, it was necessary to present web pages in a familiar guise but the time has come to move on. There is a great barrier in the way, however – the desktop. If we can ditch the desktop, we can free our minds. As graphic designer and new media director P. Scott Makela has argued: 'The desktop sucks, it's outdated, it's all about working in an early 20th-century office sweatshop.' Makela has frequently spoken out against today's software which forces users to work in boxes and rectangles, saying 'I want to swim through things and make them ubiquitous.' His work on the 'burden and protection' project with design school Cranbrook and the Massachusetts Institute of Technology highlights an alternative – it is a web page that streams full-frame video and information like a television. Makela believes that, currently, the web is little more than a scrolling newsletter and that the way forward is to immerse users in information and images just as a cinema-goer becomes immersed in a film.

Many believe that television is a better model for the web than print. Websites could act like television channels offering viewers a choice of content within one overarching structure – except that this content would all be available simultaneously. San Francisco-based Post Tool's Post TV site (www.posttool.com) is one of the most innovative in this field, with partner David Karam arguing that 'the model of a magazine on the web is pretty much hashed out'.

The broadcasting model is also utilized by what many are hailing as 'the next big thing' on the web – push technology. Push is a catch-all term for a variety of innovations which 'push' content to users as an alternative to them having to 'pull' it for themselves. Users subscribe to a channel, specifying areas that they are interested in and sites that they would like to be informed of any changes to. When the user is logged on to the internet, the channel works in the background popping information updates up on the user's screen as necessary.

This digital wire service will certainly cut down on wasted time for those who use the web as a serious information-gathering tool but will not make much impact on those who find the journey as important as the destination. The much-used 'surfing' analogy is enlightening here. Surfing is all about the journey – you reach the shore and then you paddle back for another go but you are always covering the same stretch of water, it is what happens on the way that makes it fun.

This applies to the nethead sitting in his bedroom spending hours just playing on the web but not to what is an increasing majority of internet users who sit down with a purpose in mind – a topic to research, people to find. This is not aimless; it is not like flicking channels on a television, but is more like using a library and maybe it does not need to be any more exciting than that.

Yet the logic of ditching the desktop still applies. Makela's opposition to it is based on finding better ways to present information. It is a functional argument, not just an aesthetic one. The computer desktop has all the problems of the real desktop. It gets cluttered. You cannot find anything. Nothing is ever where you thought you left it. The drawers are stuffed with things you will never need but cannot bring yourself to throw away. That vital file is never where you need it when you need it.

The solution may come via the use of 3D which is currently being explored on the web. VRML (Virtual Reality Modelling Language) allows for the construction of 3D worlds. Companies such as San Francisco's Planet 9 Studios (www.planet9.com) are pioneering the use of 3D worlds on the web which allow users to walk down streets and into buildings, to meet people and converse with them.

It is not too much of a leap to picture this model as the future norm for all computer interfaces. For years we have accepted the metaphor of the desktop because the computer was primarily a work tool. We have accepted what has amounted to little more than the shuffling of digital pieces of paper. Now that the computer is becoming increasingly essential in every aspect of our lives, should it not reflect that? Is it not time it reflected more than just our time spent working at a desk and became a reflection of our lives as a whole? Of walking and talking and meeting people and going places? The power of 3D can make that happen: it introduces notions of time and space to the computer desktop.

It does not have to be via something as contrived as a virtual city or a virtual office. Microsoft's Internet Explorer browser includes an option which allows Windows and NT users to replace their desktop with a Webtop. This creates what Microsoft calls an Active Desktop which is supposed to make using Windows more like using the web. Icons and filenames are underlined as the mouse pointer moves over them. One click is enough to open documents and launch programs. The Active Desktop also supports many features familiar from the web including animations, push technology and Java applets.

Microsoft's Active Desktop illustrates how the web is already driving innovation in other areas of computing. It is a truly disruptive technology. It has forced changes at work and at play. Its impact has been felt, and will continue to be felt, in every business, in every organization, in every nation. The following pages exhibit the work of those who are in the vanguard of this revolution. To see the future, read on.

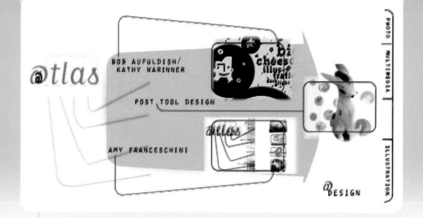

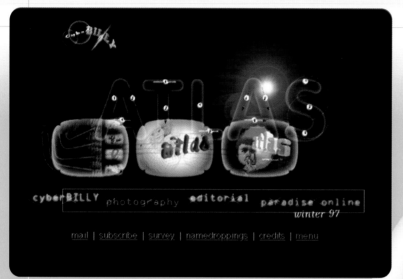

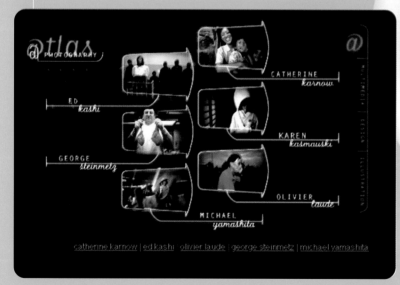

Atlas

www.atlas.organic.com

Online multimedia magazine Atlas displays the work of San Francisco's best artists, photographers, musicians, illustrators and designers.

This communications magazine really works in an interactive format and exploits the constraints of the internet, rather than being hindered by it. Every week the site is revised using the latest technology, such as Shockwave and Java.

Up to 50 designers and illustrators contribute to the look of the site at any one time. The use of low resolution files means that downloading the photography and music is relatively painless.

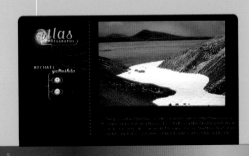

@nasa.gov

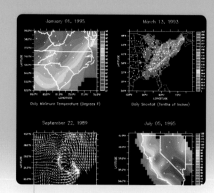

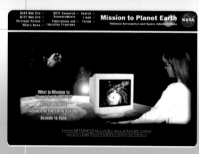

ions & Answers

Aero and

Space News

Subject Search

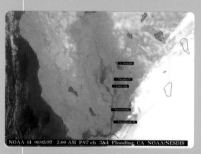

Mission to Planet Earth
National Aeronautics and Space Administration

Copyright 1996 J. Ke
kbeatty@s

SPACE SHUTTLE

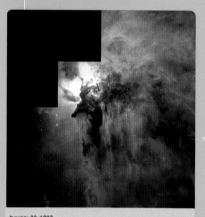

NOAA-14 01/05/97 3:00 AM PST ch. 3&4 Flooding, CA NOAA/NESDIS

January 22, 1897
Photo No.: STScI-PRC96-38a

This NASA Hubble Space Telescope (HST) image reveals a pair of
one-half light-year long interstellar "twisters" -- eerie funnels and
twisted-rope structures (upper left) -- in the heart of the Lagoon Nebula
(Messier 8) which lies 5,000 light-years away in the direction of the
constellation Sagittarius.

The central hot O type star, Herschel 36 (upper left), is the primary source
of the ionizing radiation for the brightest region in the nebula, called the
Hourglass. Other hot stars, also present in the nebula, are ionizing the
extended optical nebulosity. The ionizing radiation induces
photo-evaporation of the surfaces of the clouds (seen as a blue "mist" at
the right of the image), and drives away violent stellar winds tearing into

NASA

//bolero.gsfc.nasa.gov

Containing a wealth of fascinating information,
NASA's homepages offer viewers the chance to
explore the universe from the comfort of their
desktop. This is one of the biggest and most
comprehensive sites available on the world wide web.

The homepage contains an initial list of links, from
which the user is transported on a journey around
the solar system. Graphically, the weather maps of
the world, which are updated continuously, have
an intricate splendour. QuickTime movies of space
voyages, planets in orbit, comets, even life under
the oceans is available to download.

The information is provided in a variety of user-
friendly formats and so there is not too much
waiting around for film and images. What is more,
all the film and images are copyright free.
When there is a space mission taking place, it is
even possible to get a live television link into space.

Gallery

Photo Gallery

Video Gallery

NASA
Public Affairs

Apollo 11

Audio Gallery

-8 1 3 5 7 9 11 13 15 17 19 21 23 25 27 29 31 -8
Day of the Month: January 1995
(A) Daily Maximum Temperat
(B) Daily Minimum Temperat

J-Track Version 1.2b4

| About | Name ▼ | ☐ Day /Night | ☐ Grid | ☐ Weather |

Hubble Lat 27.6 Long -93.5 Alt(km)

UARS

5 Feb 1997 12:44:54 GMT

Click on craft	Displays orbital parameters above map
Ctrl+Click on craft	Toggles on/off ground trace
Shift+Click on craft	Goes to web page about craft

2

dribbles

ANTI-rom.
the antidote

digital cash
boys my greatness

junk
falls apart
ANTI-rom.
the antidote

ANTI-rom.
the antidote

the impossible dream
blows in your ear

your mother
comes in and out of focus
ANTI-rom.
the antidote

Anti-Rom

www.antirom.com

Produced by the young British multimedia collective Anti-Rom, this site challenges our preconceptions of the internet. Though it serves little purpose, it certainly shows off the capabilities of Shockwave. Nothing seems to stay still: film, photography, type and graphics race across the screen.

Working much like a CD-Rom, the first screen is an interface by which users can navigate the rest of the site. Though most of the action takes place on the top middle of the screen, the speed the graphics move and the beat of the music change depending on where the mouse is clicked. Clicking lower will dramatically speed things up; to the left will move things right.

Anti-Rom has a clever trick of combining four or five loops of sound to give the impression of a continuous piece of music. Simple games also play a part in the site. The electro ball illustrated above left can be thrown around your screen and makes noises as it bounces off the edges of the browser.

Designer: Andy Cameron.

John Hersey

www.hersey.com

4

San Francisco-based illustrator John Hersey has abandoned conventional portfolios in favour of the world wide web. Hersey uses his website to advertise his skills across the globe. His colourful site features examples of his work, including icons, editorial illustrations, fonts and animations, as well as his own line of t-shirts for sale.

In fact he will post up just about anything – the site sometimes even includes pictures of his family. Hersey tries to update his site once a week and gets around 500 hits a day. As he works by himself from a one-room studio, the website means that he can interact with clients without having to interrupt his work.

Hersey claims he never needs to go and see clients; instead he keeps in touch via email and fax. As one of the first illustrators to use a computer, he is well placed to take advantage of the new work opportunities afforded by the web.

monkey
business →B

slide card
(click card)

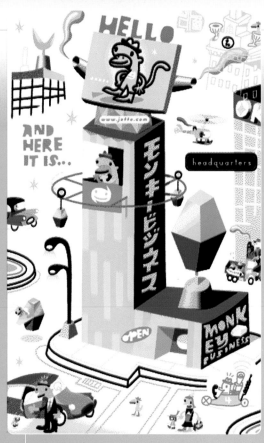

HELLO

AND
HERE
IT IS...

headquarters

www.jotto.com

OPEN

MONK
EY
BUSINESS

MONKEY
BUSINESS

Otto Seibold

ww.jotto.com

5

San Francisco-based children's book illustrator J. Otto Seibold's homepage features the quirky characters he has created. The site is split into two sections: Space Monkey, the first monkey in space, and Mr Lunch, he can't stop breaking for a snack; each has a site dedicated to them.

Jotto.com provides excellent educational links from each of his sites, while simple, low-resolution, looped animations of the characters in the stories keep the screen alive. Children are encouraged to interact with the site and stay loyal to it.

Drawings and questions may be emailed, with a reply from their favourite character guaranteed and a chance of seeing their own artwork live on the world wide web.

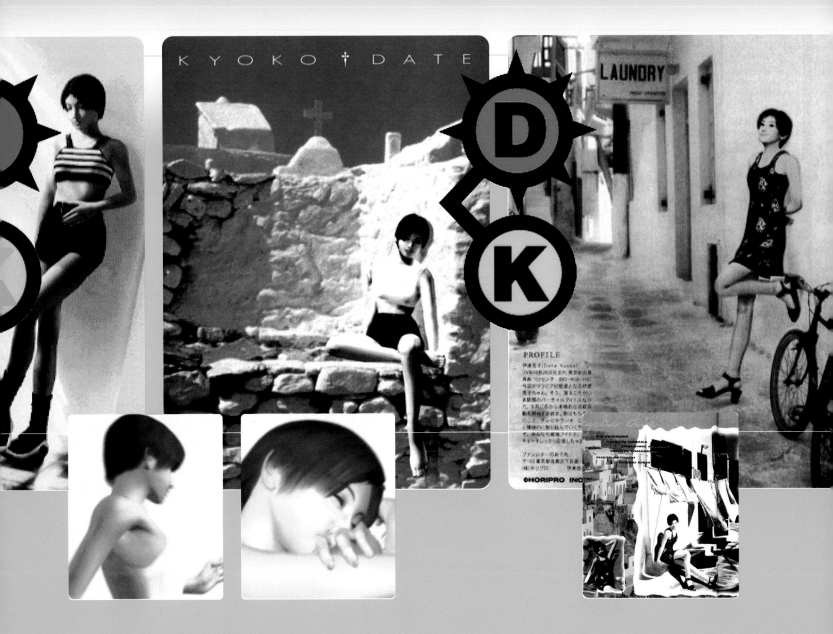

KYOKO † DATE

PROFILE

©HORIPRO INC.

Kyoko Date

www.etud.insa-tlse.fr/~mdumas/kyoko.html

Computer-generated pop star and teen idol Kyoko Date, code named DK-96, lives only on the internet. She is the first celebrity to exist in cyberspace. Created by the engineers and designers at HoriPro in Japan, she is made up of 40,000 polygons. Ten people worked to create her face alone. Fans can browse every detail of the life of this singer-come-waitress: date of birth (1979), height (1.63m), shoe size and many other vital statistics. She likes Manga and drawing and her favourite actor is Christian Slater. Users of the site can download her songs which have sold incredibly well in Japan. Kyoko Date can change to reflect the demands of her fans by getting them to vote about what they really think of her. This of course gives her creators databases of information about what the youth in Japan really want.

Unlike other teen stars Date will not drop her knickers or get arrested for possessing amphetamin – unless of course her creators intend it.

Main designers: Tatsuya Kosaka, Toshihiro Arama and Tomoya Tomadechi

3hè:

tiravanija1.html

ä

Adaweb

www.adaweb.com

Adaweb has a worldwide reputation within the internet community. It was launched in 1994 as a research development platform devoted to the production of original art projects for the web. The site takes its name from Lady Augusta Ada Lovelace, the daughter of the poet Byron.

Lady Augusta is considered to be the inventor of the concept of software. Adaweb's content is generated and created specifically for the online medium. The site collaborates with many modern artists and has produced work with major museums, including the Museum of Modern Art, New York.

The attitude of the site is summed up in the excellent 'Select A Truism' section. The user selects say, 'Even your family can betray you', and changes and improves the saying before posting it back up on the world wide web.

nly two who know this language.

Please be alert.

DRAINAGE SEQUENCE.
COMPLETE SCAN

INOCULATION SEQUENCE
COMPLETE

YOU ARE BEING REC
FOR DEFECTS... NOW

MYSTERY ENGINEERING

THE ABOVE
IMAGE SERVES
AS A LINK TO
R. FRANCIS MICHAELS'
MOST RECENT
JOURNAL ENTRY
OR OF THE CYNAPSE LABORATORY]

SITE GUIDE

01

Unit Objectives

AY ON LANGUAGE THEORY AND

be sure to take a moment and visit the web

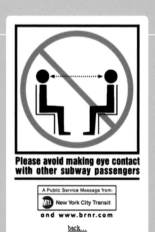

ush strangers
coming trains

Message from:
s City Transit
brnr.com

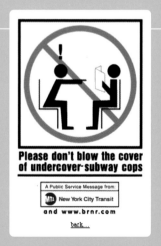

Please avoid making eye contact
with other subway passengers

A Public Service Message from:
MTA New York City Transit
and www.brnr.com

back...

Please don't blow the cover
of undercover subway cops

A Public Service Message from:
MTA New York City Transit
and www.brnr.com

back...

CAMELS BIG! FUN 'N'
ACTION MATCH PLAYSET!!

BRNR Labs

www.brnr.com

BRNR is a collection of experiments that allows freelance graphic designer Michael French an outlet for ideas that 'don't have any place in day-to-day design work'. The overall goal of the site, if there is one, has been to experiment graphically and structurally and 'to call into question the often unnecessary redundant standards of contemporary web navigation'. The end result is an intriguing collection of graphics, games, icons and signs.

Site navigation is via a grid of circles; flashing symbols in the circles are an indication as to what might be behind them. Once scrolled over, the section head appears discreetly on screen – no need for nasty hotlinked words. French injects plenty of 'designer's' humour into his site. Sections such as the United Users of Gaussian Glow or (UUGG) ask the user to view a thorough assessment of glow technology in new media –

click on the icon and the essay behind is complete illegible. Other content includes his pointless experiments with colour in the Self-Indulgent section and his ridiculous products, such as the wood simulated matches. At BRNR French proves that good-looking and meaningless can still be fur

RODUCT

x x x

Aerospace Construction/transportation

MANTIC DEVELOPMENT...

avorite graphic design organizations:

| D.U.L. | u.u.g.g. |

X1
X2

SELF-INDULGENT

S
CKS WITH
IN
E TIPS
IT)
C MATCHBOX
E

(he knew me to b a musician) and to pleas
would be so kind cast it out of me. I was
athlete in high shool, nor a Casanova wit
grade-hungry, diigent student, so my musi
way, was as far rom devilish as one could
studied music thory and played in a 50s-s
even played clasical on the side) was the
made me feel realy good about myself. I w
give it up. God is now a scary one, and I
do with him. Thu ended my foundation in t
religion.
 For the reminder of my high school y

一心慕歌自

千成祈求千處愿●苦海常作渡人舟

豆消

:bool
bore

eggs, and fanc
till didn't fe
school, a pup
an with a whol
ime," they sai
ght I experie
under the head
lly retouched
me clouds, say
!" This was no
d me in a swee
ng to Jesus th

le **Edit** View Label **Special**

tscape: Live from the streets of

Config PPP

| Open | Soft Close |

PPP
UP | Stats... | Hard Close |

Port Name: Modem Port ▼
Idle Timeout (minutes): 10 ▼
Echo Interval (seconds): Off ▼

☐ Terminal Window
☒ Hangup on Close
☒ Quiet Mode

ver: Demon London ▼

| Config... | New... | Delete... |

v2.0.1

Netscape: HOST Ne

◁o o▷ ⌂ (C
ack Forward Home Reload

9 items 99.7 MB in disk

Name

▷ 📁 Applications
▷ 📁 Internet
 🗒 minirun.ani.gif
 📄 Picture 1
 🎵 QuickTime™ Musical Inst...
 SimpleText
In compliance with the National Aeronautic
▷ 📁 System Folder Networks hereby de
with 📁 National Aeronautics an
▷ 📁 • Filing Cabinet

HOST Networks has no con

MAIN MEN

1. LIVE Cameras Ar

2. Animated Satelli

3. General Intere

Document : Done. 20% of 62K (at 1.2K/sec , 42 sec

'type 1' error occurred

Restart

Swarm

Run Default Values

Length 300 (060-300)
Height 300 (060-300)
Num. Critters 030 (003-072)
 Run

fusebox.com

web architecture programming design marketing hosting

view our sites

Demons

Run Default Values

Length 100 (020-100)
Height 100 (020-100)
States 009 (006-072)
Size 003 (001-003)
 Run

Fusebox

www.fusebox.com

American web design company Fusebox was so inspired by the work of programmer Chris Reynolds that it set up its own artificial life page. In 1986 Reynolds invented a computer model to coordinate animal movements, such as those of shoals of fish. He named the software Boids. Boids was based on 3D computer geometry (the kind used in computer animation or CAD).

The premise is that each Boid has direct access to the whole group's geometric description but it will only react to 'flockmates' close to it. There are three main steering behaviours: Separation, Alignment and Cohesion. The Boids program formed the basis of the software that created swarms of bats in the Hollywood movies *Cliffhanger* and *Batman*.

Now even someone without the slightest grasp of mathematics can experiment with this on the Fusebox artificial life page. Set up your own swarms and shoals and watch how they behave. Users can specify, within reason, the amount of Boids, their length and how fast they should move. New additions to this page include simple morphing programs.

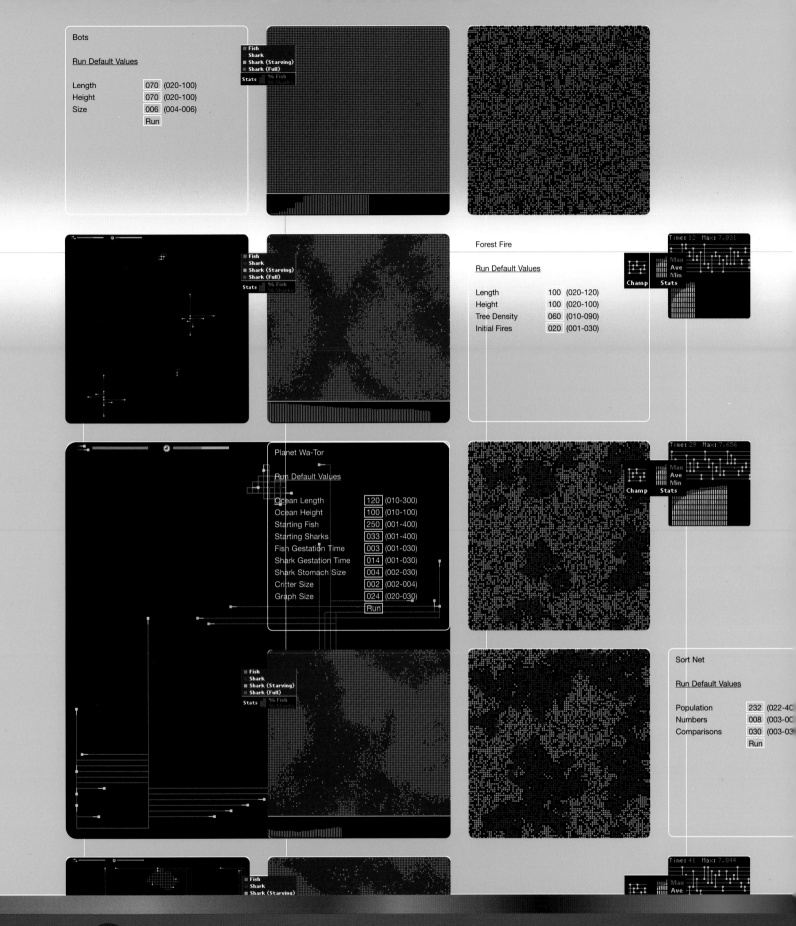

Bots

Run Default Values

Length	070	(020-100)
Height	070	(020-100)
Size	006	(004-006)
	Run	

Forest Fire

Run Default Values

Length	100	(020-120)
Height	100	(020-100)
Tree Density	060	(010-090)
Initial Fires	020	(001-030)

Planet Wa-Tor

Run Default Values

Ocean Length	120	(010-300)
Ocean Height	100	(010-100)
Starting Fish	250	(001-400)
Starting Sharks	033	(001-400)
Fish Gestation Time	003	(001-030)
Shark Gestation Time	014	(001-030)
Shark Stomach Size	004	(002-030)
Critter Size	002	(002-004)
Graph Size	024	(020-030)
	Run	

Sort Net

Run Default Values

Population	232	(022-40
Numbers	008	(003-00
Comparisons	030	(003-03
	Run	

9

Discovery Channel

www.discovery.com

The Discovery Channel online is in every way an extension of the television channel. A panel on the left-hand side of the site promotes the channel's worldwide programming and network. The rest of Discovery Online offers comprehensive 'edutainment' which is updated daily. While interesting and informative to every age group, the site's programming is really aimed at school children.

There are six sections to choose from: history, technology, wings, nature, exploration and science. There is a search engine provided on the site, if you are looking for something specific. In each section visitors to the site are encouraged to give their opinions or tell stories, for example, 'Tell us about your animal encounters' or 'What is the most trivial history fact you know?'

The site is demanding in its use of leading-edge technology: at the time of writing, to see it in its full glory requires Shockwave, RealAudio, Netscape Navigator 3.0 or later, QuickTime, Bubblevision and Vxtreame. Doubtless these are being upgraded as you read. Fortunately, users ca_ still get plenty out of it without any of the plug-ins

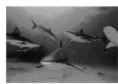

WIRED

WILD DISCOVERY

This Week:
Sharks Ain't Misbehavin'

Talk to shark expert Gilbert Van Dykhuizen, right here April 27 - May 3.

Shark shapes
How have sharks evolved over the past 350 million years?

Deep-sea demeanor
What makes sharks such successful predators?

Shark conservation
What is being done to ensure their survival?

Sharks are the victims of a bad rap. Although most species are harmless to humans, the behavior of a notorious few, especially the great white shark, has given the creatures their reputation as toothy monsters of the deep. Much of their infamy can be traced to the 1975 movie *Jaws*, featuring a relentless great white who terrorized the waters of a small seaside resort. But it is more likely that their bad eyesight, not their evil nature, causes sharks to attack humans on occasion. Sharks can mistake humans for seals or sea lions because they are unable to see with their jaws open. In actuality humans are more of a threat to sharks than vice versa, and many species have been hunted onto the endangered list.

"Sharks of the Red Triangle" is on this week's *Wild Discovery* series. Tune in every night at 8 p.m. ET/PT.

Gilbert Van Dykhuizen is a research biologist at the

Discovery Online 🌐 —— History | Technology | Nature | Exploration | Science | Live !

Nature

| Conversations
| Previous Stories

Big Fish, Big Pond, Big Lie
Are shark and man mortal enemies? Who should be afraid of whom? Our "Wild Discovery Wired" expert is here to rehabilitate a wretched reputation.

Elephants: Stomping Contradictions
They're big and they're gentle. They're fat and they're agile. They're like living dinosaurs, and they're here for you to check out.

Discovery Online 🌐 —— History | Technology | Nature | Exploration | Science | Live !

Exploration

| Conversations
| Previous Stories

The Dead Sea by Bike
Jim Malusa is winding down his month-long bicycle trip to the Dead Sea. There's plenty to see whether you've followed from the start or just found him today!

We're Off to Yosemite, Ma'am
Well, OK, because it's there ... but also because it sounds like a blast to say we've seen the top of El Capitan.

Discovery Online 🌐 —— History

Tech

I'll Wait for the Plane, T
In 1969 the New York Jets jetpack was ready for consu were 1-15 and jetpacks wer warehouses.

Look, Up in the Sky ... It
He was one of the first hun once those Wright Brothers

Discovery Online 🌐 —— History | Technology | Nature | Exploration | Science | Live !

GONE
to El Capitan

by Dougald MacDonald

Coming Next:
On May 6, David Tracey seeks the Sword Man of Kamakura

Chris McNamara's headlamp flares intermittently above, like a lighthouse in the distance. The ropes slither across the smooth granite when he moves. Otherwise I'm alone, dangling in the dark by a thin nylon rope a half mile above Yosemite Valley. It's our third day on El Capitan, and we're climbing into the night, racing to the top, chased by nasty storm clouds.

But we're using a method that's never been tried here, climbing without the safety of pitons. And the final section of the rock is the most risky.

click on photos to enlarge

The part of the concave southeast face of El Capitan we're climbing is the North America Wall, a route named for an intrusion of dark grey diorite forming what looks like an immense map of the continent on the peak's white granite. (Climbers enjoy the privilege of naming geographic features on either side of the North America Wall are the Pacific Ocean Wall and Gulf Stream, a line up the East Coast is called the New Jersey Turnpike.) Yvon Chouinard and Royal Robbins helped set a new standard for difficulty when they pioneered this wall in 1964.

But they and every climber since have pounded piton after piton into El Capitan's cracks to aid their ascents. Pitons come in various designs. One type is a metal spike with an eye on one end – somewhat like a giant sewing needle – hammered into the rock and threaded with climbing rope for safety. These hardened steel blades and wedges eventually scarred the seemingly impregnable granite with lines of ugly holes. Our goal is to apply a new style, "clean climbing", and hopefully convince others to halt the damage to the rock.

Discovery Online 🌐 —— History | Technology | Nature | Exploration | Science | Live !

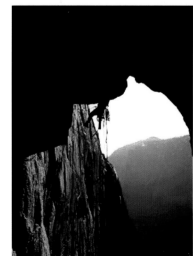

Discovery Online 🌐 —— History | Technology | Nature | Exploration | Science | Live !

Eye On the Road
Florida
Monday, April 28, 1997

Photograph by John Curry/ Silver Image

Gallery

Two Idea Clara butterflies feed on the nectar of a jatropha flower.

Use scroll arrows to follow the dotted line...

ScrollBar Animations

www.dorsai.org/~jkurland/
thedottedline.html

Created by Artworks in New York, The Works showcases art in a digital age. The site's contents are diverse. One of the sections recommended for Browser were the ScrollBar Animations, otherwise known as The Dotted Line.

The animation works using the same principles as a flip book. Instead of flicking through pages of images, the illusion of animation is created using a never-ending web page and the scroll arrows – devastatingly simple but effective.

The Dotted Line is a single line of dots and bubble running through the centre of a page. To view it in action, you begin scrolling down the page as the page moves up, and the line begins to pulse and throb.

Project Description

Hidden Motions is a interactive cinema project we created for the 'exploding cinema' part of the Film festival Rotterdam 1996. I (Keez) made the concept, invented the main idea. Bum Beekman, Ivar van Hoorn, Matthieu Hes & Gerwin Niessink participated on the actual production.

Interactivity

Hidden Motions is a multilayered linear film. it uses the same technology as the Anaglyph: 'A stereo image that requires glasses with red and green (or blue) lenses for 3D viewing. The two stereo images are printed on top of each other, but offset. To the naked eye, the image looks overlapping, doubled and blurry. ' In my concept the viewer has glasses with two green lenses with an small red visor instead of two different colored ones. The viewer makes his own layout of the film, which is a combination of the two images, based on his interest in onscreen elements.

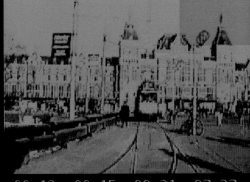

Hidden Motions is an interactive cinema project created by Keez Duyves for the exploding film festival in Rotterdam in 1996. It is a multi-layered, linear film that uses the same technology as the Anaglyph, a stereo image that requires glasses with red and green lenses for 3D viewing.

The two stereo images are printed on top of each other, but offset. To the naked eye the image looks overlapping and blurred. 'In my concept the viewer has glasses with two green lenses with a small red visor. The viewer makes his own layout of the film, which is a combination of the two images, based on his interests in on-screen elements.' A demo of how the film works and the details of the project are contained in this site.

@art

Welcome to @art, an electronic art gallery affiliated with the School of Art and Design, the University of Illinois at Urbana-Champaign.

This gallery is curated and maintained by the faculty members Nan Goggin and Joseph Squier, who function collectively as ad319. Our intention is to encourage artists' involvement in the global electronic community, and to provide an electronic viewing space for talented artists of outstanding merit.

▶ Current Exhibition

▶ Archive

▶ Other ad319 Projects

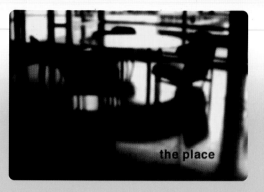

the place

The Place

//gertrude.art.uiuc.edu/ludgate/
the/place/place2.html

The Place is an evolving repository of artwork created specially for distribution on the world wide web. The Place is the brainchild of Joseph Squier who launched it in September 1994. Squier is a teacher of photography, video and electronic image-making at the University of Illinois.

All the content from his virtual gallery is free to be distributed. The installations within The Place range from interactive books in the Soapbox section, to explorations of human anatomy. The Urban Diary section of the site is the most absorbing. Urban Diary chronicles the life and thoughts of an anonymous citizen.

The diary's true meanings are known only to the original owner. Many of the images on the diary pages and most of the circled items contain hyperlinks. The Place was developed on a Mac platform and is best viewed that way. The preferred browser is Netscape.

^

< >

v

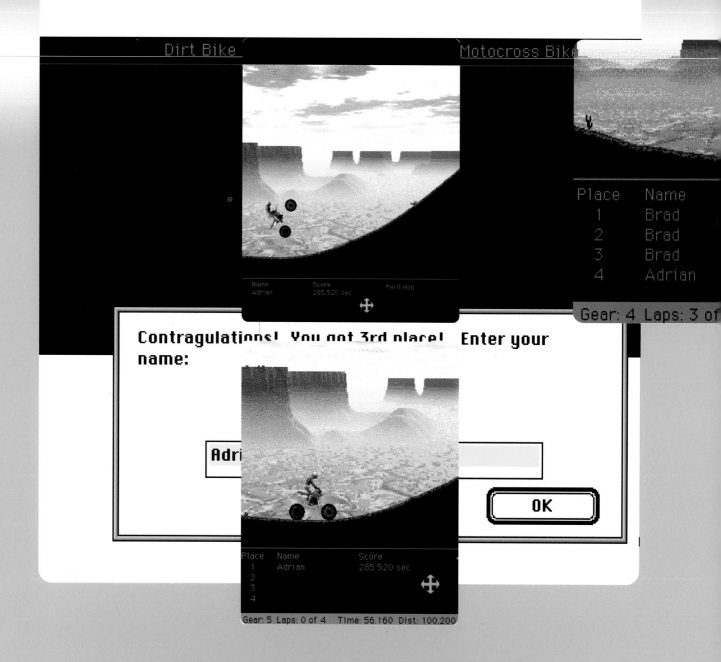

There are thousands of free games available on the internet. Here is one we like.

Score
20.740 sec
27.886 sec
45.098 sec
96.260 sec

*Standard Track: This is the default track. If you
hit the second set of jumps in 4th gear, you can
clear three jumps at once.

e: 43.770 Dist: 439.000

Place	Name	Score	
1	Brad	20.740 sec	*Standar
2	Brad	27.886 sec	hit the s
3	Adrian	30.190 sec	clear thr
4	Adrian	31.960 sec	

Gear: N Laps: 0 of 3 Time: 10.230 Dist: 14.350

Anonymous

Welcome to the Net's first, free hi-fi music archive.

It's Fun! It's New!

Sign-In.
Woo Hoo!

Enter
IUMA
at high speed with
rich graphics...

Enter
IUMA-lite
at low speed with
slim graphics...

IUMA is the one stop for all your Internet music needs.
Check in with the latest musicians in our New Arrivals section.
Now Liquid Audio enriched!

Powered By

© 1996 Internet Underground Music Archive - All rights reserved - IUMA 2.0

The Internet's pad for Hi-Fi living.

BAND OF THE WEEK GAME SHOW
-Enter-

WE'RE NOW SECURE! Check our catalog of merchandise on the Ordering Info page.
Reduce your bandwidth with IUMA-lite or if it's your first time try the Guided Tour.

1,[H]UMAN
VOLUME 2.03

Pick From One Of
Our Other Issues V.1.01

LESS SPAM THAN THE LEADING eNEWSLETTER

COOL EXTRAS
...go ahead, put your feet up on the desk
and enjoy a nip of smooth velvet goodness.

Publications

ELECTRONIC PUBLISHING, it's the dope.
IUMA is launching these publications into cyberspace.

-Real Audio-
Anubis Spire, "It Has Been A Long Time, Hasn't It"
Experimental, New Age, Progressive Rock, World Beat
Greene, New York, USA
Date Uploaded: 1997-03-04

-Real Audio-
BEYOND BEYOND, "E-Z Come, E-Z Go"
Progressive Rock, Rock, Electronic
St. Petersburg, Florida, USA
Date Modified: 1997-03-28

IUMA's VISION of a level playing field
begins here with more than 878.2 independent artists online.

Choose a genre and press "Go," or mingle in the party above.

All Genres
A Cappella
Ambient
Blues
Children's
Classical

Go!

IUMA bills itself as the internet's first free hi-fi music archive powered by Netscape, Silicon Graphics, Web Condo and enriched with Liquid Audio. IUMA or International Underground Music Archive was founded in 1996. Pull up the homepage and you are faced with three options. Sign in, to become a member of the site. There are no obligations; it states quite clearly, 'You will receive no calls from vacuum cleaner salesmen', instead you will be served better.

The membership questionnaire is long but lighthearted: questions range from, 'Would you like to receive the IUMA newsletter?' to 'Why are you on earth?' IUMA offers two routes through their site, one option high speed with rich graphics, the other low speed and slim graphics. Either route will lead you to five sections. 'Bands' contains information and sound samples from independent artists around the world. There are several ways of searching this: select a genre (these range from

Rock to Weird), input the name of a band you wish to find or conduct a random search. Other sections include record labels, publications and what's brewing. There is also a band of the week section sponsored by Levi's.

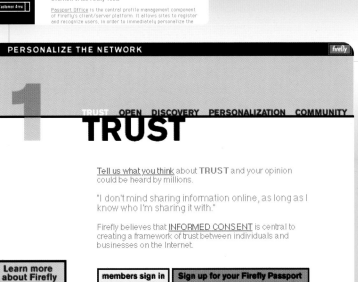

It's all about you.

If you are already a member, sign in. Otherwise, take a moment to learn more about what Firefly can do for you.

Problems getting in? Question or comment? Tell us what you think!

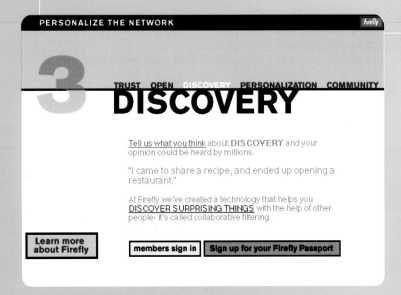

PERSONALIZE THE NETWORK — firefly

1

TRUST OPEN DISCOVERY PERSONALIZATION COMMUNITY

TRUST

Tell us what you think about **TRUST** and your opinion could be heard by millions.

"I don't mind sharing information online, as long as I know who I'm sharing it with."

Firefly believes that INFORMED CONSENT is central to creating a framework of trust between individuals and businesses on the Internet.

Learn more about Firefly | members sign in | Sign up for your Firefly Passport

PERSONALIZE THE NETWORK — firefly

3

TRUST OPEN DISCOVERY PERSONALIZATION COMMUNITY

DISCOVERY

Tell us what you think about **DISCOVERY** and your opinion could be heard by millions.

"I came to share a recipe, and ended up opening a restaurant."

At Firefly we've created a technology that helps you DISCOVER SURPRISING THINGS with the help of other people- it's called collaborative filtering.

Learn more about Firefly | members sign in | Sign up for your Firefly Passport

PERSONALIZE THE NETWORK

5

TRUST OPEN DISCOVERY PERSONALIZATION CO

COMMUNITY

Tell us what you think about **COMMUNITY** and your opinion could be heard by millions.

"If the Internet is so packed with people, how come don't see anyone around?"

Firefly is about people's opinions. Technology is fine, but nothing can replace the perspective of another human being.

Learn more about Firefly | members sign in | Sign up for your Firefly Passport

Firefly is an intelligent agent that thinks it is your friend. The language of the site is designed to grab the user's attention and draw them in. The first screen instructs you to 'Imagine a world made to order, a world designed specially for you filled with the things and people you like'. It is hard not to be intrigued. It continues: 'The Firefly passport is your ticket to the world. Use it to shape your experience in any way you want; it's all yours.'

How? Firefly works by monitoring your behaviour on member Firefly sites. As you explore, the software is recording your tastes and preferences and starts to predict what you might like. As part of the deal every member of Firefly gets their own web page that can be filled with anything. Firefly is helping to pioneer user trust in interacting with the internet.

Many people are not keen to have their personal details given out over the internet, so Firefly promises not to use your email number outside the network; and there is no need to give details of where you live to use the network.

Created by the Firefly Network Inc.

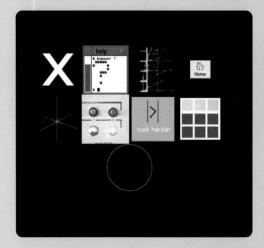

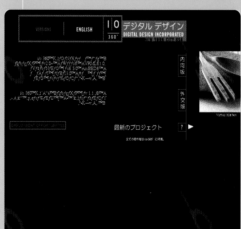

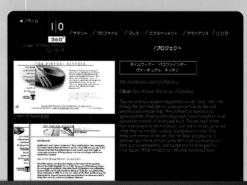

i/o 360

www.io360.com/v2/yo

i/o 360 is a digital design company based in New York City. Their own site contains their portfolio but is largely experimental. As a result, getting the best out of it involves the latest plug-ins. However, there is a version for those working with low bandwidths. Some of the images pictured above are taken from the Ascii World section of the site.

Ascii World works in two ways. In the Transformations the user is invited to type in a word or sentence and then see it transformed into text or code from a bygone era. There are over a dozen transformation codes to choose from, ranging from Morse, to Nam-Speak and Paper Tape. The Gifscii section goes one better – it changes images into code. When you enter the URL of an image, Ascii World

will check the URL, fetch the image and then convert it to an Ascii representation. This might take few minutes, depending on how long it takes to find the image. JPEG images take a bit longer tha GIFs. Users are free to upload an image for conve sion from their local computer.
As Elvis proves, it works really well on faces.

I|O

Jodi

www.jodi.org

Jodi is the creation of Dirk Paesmans and Joan Heemskerk. They are the sole contributors. Their objective is simple: they aim to create 'no content'. However, in the quest to create nothing they have said more than most. After all, how many internet sites are of any real use or make any real statement in the first place? How many really look good?

Jodi's pages of abstraction and code at least serve as interesting viewing, as well as challenging the user to think about where they are going to be transported next. What they are going to find is entirely unpredictable. If you can find it there is a page of links Jodi recommend or have contributed to.

These tend to be arts-based projects or research sites based in Europe. Like Jodi, all of these are striving to establish the internet as a global forum for creativity.

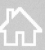

gusGus
BELIEVE
1.BELIEVE 2.OH 3.COLD BREATH '79 (Craze) 4.GHETTO BELIEF

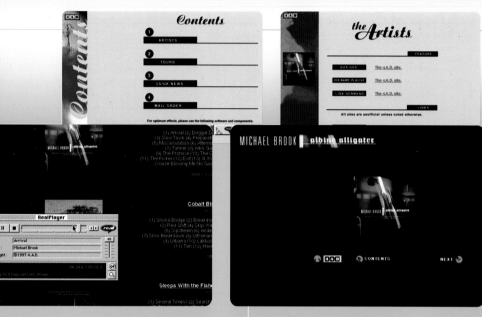

MICHAEL BROOK | albino alligator

music from and inspired by the Miramax motion picture Albino Alligator
a thriller directed by Kevin Spacey

London-based Indie record label 4AD effectively uses its website to extend the brand online. There are four main sections to the site: Artists, Tours, US/UK News and Mail Order. Each artist featured on the site has their pages individually tailored for them.

The styles are contrasting and vibrant. Only the type remains constant throughout the pages. This acts as a subtle reminder to the viewer that they are surfing the 4AD pages. Content for the artists' sites include details of their latest album release, tour dates, a biography, photographs and a complete discography.

If the artist has released a video, it will be available on their site as a specially adapted web movie in Shockwave. The sites are peppered with sound files which can be accessed using RealAudio.

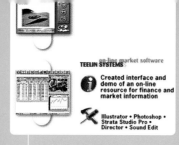

TEELIN SYSTEMS
on-line market software

Created interface and
demo of an on-line
resource for finance and
market information

Illustrator • Photoshop •
Strata Studio Pro •
Director • Sound Edit

⊕ MAIN HUB ✈ Q☺⚡◉⊕✛

QASWA

CREATE

EMPYREAN

RHYTHMOS

SCHEMATA

⊕ NEXUSES ✛ Q☺⚡◉⊕✛

THE NEXUS OF NEXUSES

SHOCKWAVE HUB ⟷ STANDARD HUB

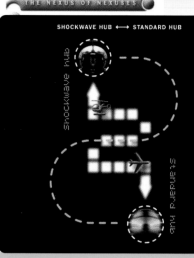

welcome to yang

YANG SNOWBOARD CLOTHING

Yang team riders and best
snow conditions updated
live by Gary & Martha
from their Tahoe winter
home.

Photoshop • Illustrator •
Strata Studio Pro

BACK

ambient guru

Ambient music has been around for
centuries, take the call of Whales, or the
drone of a dijereedoo, it's only recently in
the 70's that 'ambient' has been used as a
term to classify music. Brian Eno was, in
the main, responsible for this, with his
concept of threshold hearing. Eno was
very influenced by a generation of
composers whose work came to
prominence in the 60's - the minimalists,
central of whom is the california based
composer Terry Riley.

Question :
Basically tell us who you are.

Terry Riley :
Well I guess my music came to
prominence around one piece called 'In C'
which I wrote in 1964 at that time it was
called 'The Global Villages for
Symphonic Pieces', because it was a piece
built out of 53 simple patterns and the

**An Introduction
to Rhythmos**
a brief history of the
san francisco based
music and culture zine

Terry Riley - ambient guru
interview with the godfather
of ambient music

Qaswa

www.qaswa.com

20

Created by Ammon Haggarty of Qaswa
Communications, San Francisco, qaswa.com
serves as a 'repository' for Haggarty's personal
interests and works. The site is based around the
idea of community and 'represents an early step
towards a vision of a dimensional virtual community,'
says Haggarty. He is working on an update of the
site which will present the content in an even more
multi-dimensional and interactive setting.

The site is divided into two 'hubs', a Shockwave hub
and a standard one. From here the user connects
to the main hub. The user can check out the online,
print, 3D and offline work produced by Qaswa.
The Create section houses 'an artist's environment
for creative expression'. Empyrean was still under
construction at the time of going to print, and will
be a VRML environment.

Rhythmos is an online magazine that produces
articles and interviews around the history of San
Francisco's culture and music. In Schemata the
latest web software is tested and discussed.
Finally, there is the obligatory section of links.

Expect the unexpected on Keez Duyves' Dynamic Site. There are so many different images and links spinning and animating across the screen that it is hard to know what to do. Then frenzied mouse clicking begins. The images at first seem to be part of one block, as the user clicks different sections of the screen stop and start.

There are links hidden behind some of the graphics. As by now readers may have guessed, Keez is a Shockwave master. Though his site contains experimental work, he offers up some great ideas for user navigation online. The Dynamic site is written in Shockwave and there are links to his other Shockwave experiments.

Each one demands the full attention of the user. The graphics for the most part are kept black and white, which speeds up access to the pages.

they squeeze

my

a'ppendage

smokin japanese babes

303 whip

Future Sound of London

//raft.vmg.co.uk/fsol

Leading British techno outfit The Future Sound of London have no set rules for navigating their site. The user is expected to just leap in. A grid of asterisks in the top right-hand side of the page acts as a guide through the experience. Simply select one and click; where it will take you is anybody's guess.

Once an avenue has been explored, the asterisk changes colour and then changes back again, becoming a non-linear experience. For an act that produces digital music and digital imagery for their album covers, there can be no better means of promotion than the internet. There are dozens of sound files available from the site; transmissions range from 50 to 500k, so there is something for everyone.

Other content includes stills from the albums, sound toys, QuickTime movies and animations; plenty of information about the band is hidden within the pages.

Graphics: Buggy G. Riphead

scape

| 3 items | 1.4 GB in disk | 532.4 MB ava |

red.mov scape slider.qt

the truths/untruths

E.B.V TEXTURES

the stank series being collected together from around the world by ebv is the study of decaying microscopic
life-photographic work from India ,Sri Lanka ,Hawaii ,Canada ,London, Egypt ,Spain-this will form a series of texture
roms-released by ebv -intended as supplements to your 3d work-so wrap em round your balls

E.B.V TEXTURES/copyright95ebv--- All these textures are intended for domestic use only and should not be used for
commercial purposes.

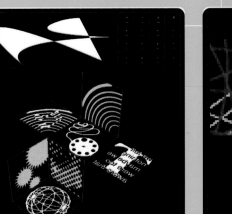

Textures

Environment

name	pixels	size	colours
cloud	425x223	47kb	256
dry	425x283	131kb	256
skyfire2	425x283	76kb	256
fungas	425x283	131kb	256

Slice Toy

slice

Size	560 kb
Type	Projector
Requires	Mac
Archive	.SIT

slice P

Size	304 kb

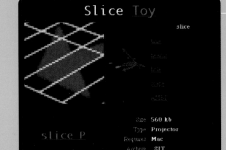

Toys

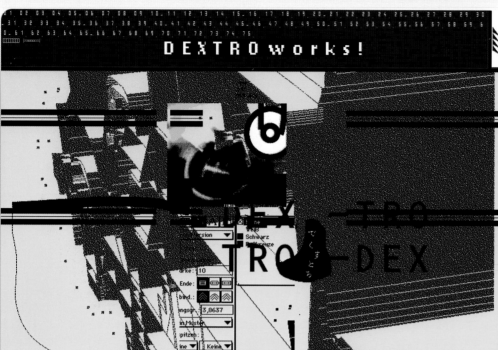

Dextro Organisation

www.dextro.org

At Dextro works! prepare to experience online graphic art at its most abstract. Based in Vienna, Dextro shows only his own non-commercial work, something that is really quite rare on the net. There are over 70 pages of Dextro's work to browse. A panel of numbers frames the top of the page. Select one and then wait to see what appears in the centre of the page.

It could be an image, poster, website, audio or QuickTime movie. There is no information available on the site informing the user why pieces were created or indeed what anything is for. In this way Dextro works! simply exists. The bottom of the frame contains a panel of links to similar experiences, all of which are well worth a visit.

Dextro works! has developed a neat way of showing websites from within their own page. Click on a link, and instead of creating a separate new page, the site appears in the centre of the page in the same way as Dextro's own work and framed by his interface.

Sorr

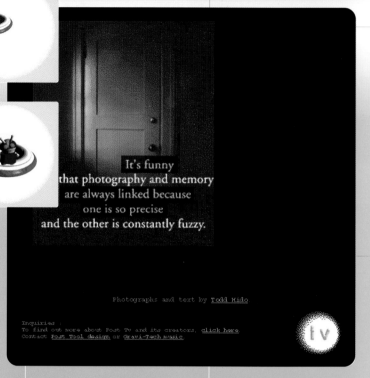

It's funny
that photography and memory
are always linked because
one is so precise
and the other is constantly fuzzy.

Photographs and text by Todd Hido

Inquiries :
To find out more about Post TV and its creators, click here.
Contact Post Tool design or Gravi-Tech music.

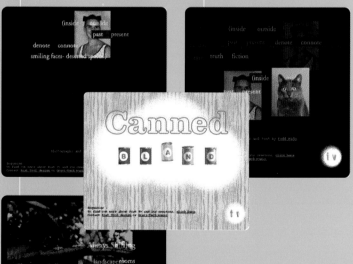

Post Tool

www.posttool.com

24

Post Tool is a design company based in San Francisco. Its website is an on-going project created by Post Tool designers and founders David Karam and Gigi Biederman, with some help from their friends. This is a self-styled site of the future, taking the format of a television show called Post TV. Currently there are seven shows available on Post TV.

There are lots of contributions to the site from local artists who create presentations especially for the internet. Tom Bland, of Gravi Tech Music, has written all the sound for the site and hosts his own show, 'Canned Bland'. For more standard fodder readers might like to try the Play Pages where, if you are feeling nostalgic, you can have a go at Pong or Space Invaders.

If users are blessed with Shockwave, there is computer-assisted drawing with Terbo Tool. Karam's idea of a good time on the internet is the Death Patrol which he set up with his buddy Terbo Ted. Their mission is to crack the passwords on corporate websites and change the homepage links, so that when they are clicked the user gets the message 'Cracked by the Patrol'.

A simple site that uses the latest Java technology, Java Poetry was inspired by the Magnetic Poetry Kit created by Dave Kapnell. The Magnetic Poetry Kit consists of different words and letters with a magnetic backing, which can be mounted on a fridge door and arranged into the stanzas of your choice.

The online Java version works as a click-and-drag game. Layers of words appear in a jumble – you simply click and drag the words together. The resulting poem may be emailed to Maria Winslow, the site's creator, and put in the Poetry Gallery, where users may browse the ramblings of fellow surfers.

Winslow's code to the site is provided via a link. This code is given away in a non-commercial capacity. Earlier versions of the site are also available to those without the latest Java plug-in.

New York

New York

London

Imola

London

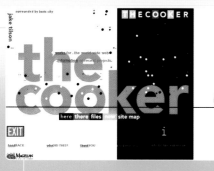
surrounded by basic city

jake tilson

THE COOKER

works for .the world wide web
information on recent projects.

the cooker

here there files now site map

EXIT

feedBACK whoDID THIS? thankYOU

MAGELLAN

i

TRANSPORT ➜

TRANSFIG...

IS

dip dip dip dip dip dip dip dip dip
dip dip dip dip dip dip dip dip dip
dip dip dip dip dip dip dip dip dip
dip dip dip dip dip dip dip dip dip
dip dip dip dip dip dip dip dip dip

ift Usage :vaporated
Gain Diversity Scan Diversity Pad
Selection Each Subsequent Selectable Printing Capable Multiscan
Last Post Quit The Scene Vamoose Make Tracks Error-status indicator Alpha Numeric Menu-driven
rate Circuit Topography Mute Patches Depth Fader Talkback Instant Reset Latching

Skip End Time Shift Usage Evaporated
Presence In-Line Gain Diversity Scan Diversity Pad
Glossy Optic Close up Persuasion Output Selection Each Subsequent Selectable Printing Capable Multiscan
Departure Walk-Out Getaway Last Post Quit The Scene Vamoose Make Tracks Error-status indicator Alpha Numeric Menu-driven
Autolocation Keypad Noise-free Operation Dynamic Range Bit-accurate Circuit Topography Mute Patches Depth Fader Talkback Instant Reset Latching

Frequency
Concious Auto
Jackfield Stripper Encoder Audio
Panner Deckfield Transport Selection Panscan
Intercom Data Protection Circuitry Synchro edit Shuttle Dial
Limiter
In Out Detection Signal to Noise

r Encoder Audio
rt Selection Panscan
edit Shuttle Dial

Studio Pod
Electro-voice Pop Sheild
Line tester
Heatshrink Bloak Universal Co... Board
Wire Size
Numbering SchemeUprigh...
2-line encoder

Generato... detecto... d Processor Dedicated Loop sor De...

ATLAS

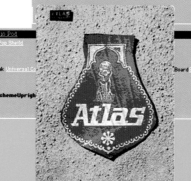
Atlas

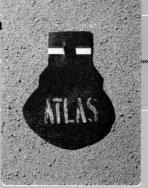
ATLAS

アトラス

The Cooker

www.thecooker.com

Jake Tilson's sites for the Ruskin School of Drawing and Fine Art and his personal creation The Cooker have attracted much interest in the online community and beyond. Tilson is a graphic artist who has thrown himself wholeheartedly into the internet, producing pages that are both visually rich and technically competent.

Tilson's philosophy for achieving great web design is a simple one: 'You have to be able to program HTML as well as being able to write it'. The Cooker contains an array of graphic explorations and simple games, for example Cookie, a piece created specially for the web. Users must simply choose a fortune cookie from one of three bowls and sit back and await their message.

Before your message appears, ponder this: Tilson scanned 150 fortune cookies to make up this site. The pages that he has created use both Shockwav... and Java and are best viewed with the latest browsers. Tilson teaches part-time at London's Royal College of Art.

Pisa

New York

Goteborg

Brussels

Oxford

Citycycles

Brussels

Tokyo

Rubbish
Toilet
Skip

Paris

Jake Tilson

cityviewers ... the project

New York

Faenza

COOKIE

DO YOU FEEL LUCKY ?, TAKE WHATE

TRY BOWL 1
TRY BOWL 2
TRY BOWL 3

WARNING
not suitable for persons
under 18 years old
USE COOKIE ®
ONCE A WEEK ONLY

bookworks

city picture fiction

parisnew yorklondon

city picture fiction

Locations

PARIS 14.11
Musée du Louvre
Ground Floor, Denon Area
Greek and Etruscan Antiquities
Saturday 18th March 1995, 11.00 am

NEW YORK 4.23
The Metropolitan Museum of Art
Great Hall
Thursday 17th November 1994, 2.00 pm

LONDON 9.43
Tate Gallery
Sackler Octagon
The Reduction of Form
European Sculpture 1913-40
Friday 29th September 1995, 11.30 am

parisnew yorklondon

HARD COPY

MEN ONLY

FLEA

Aberdeen

Cookie Comeback............
what was your luck today? appropriate news
what news do you expect next time?
 a cornmeal cookie
send your hope to send hopes
to reset the form, press this button Reset

New York

HAMMARS

Goteborg

Rome

TRY BOWL 1 TRY BOWL 3

New York

Cortona

GET OFF TO A NEW START
COME OUT OF YOUR SHELL

26

With Mapquest you need never be lost again – provided of course that you can access the internet. Mapquest is an interactive map of the world that allows the user to browse through a mind-boggling three million locations worldwide. The Interactive Atlas allows the user to search for a location almost anywhere in the world.

First select a country, then add the postcode and address of the location. With the Java Atlas, however, users can zoom in and out of locations; the personalized map utility has over 80 customized drag and drop icons. The Java Atlas is best viewed with Netscape 3.01 and Microsoft Internet Explorer 3.0. GeoSystems has compiled a digital map base of over 565,000 miles of road in 48 states of America.

They also have information on local parks, national sites and water bodies. Viewers can use Mapquest to customize information on their own map, adding landmarks and places of interest, and can copy the GIF image created on to the hard disk of their computer.

GeoSystems Global Corporation (US)

Matt Mullican

www.documenta.de

Documenta is one of the most important festivals of contemporary art in Europe. It takes place every five years in Kassel, Germany. Since Documenta V in 1972, each exhibition has been commissioned by a different curator. Mme Catherine David has headed up Documenta X.

1997 is the first year that internet work has been commissioned for the festival, a fact which reveals the growing acceptance of internet installations as a recognized art form. All of the internet work can be viewed on the Documenta website. The work is varied and of a very high standard.

Matt Mullican's piece (pictured above), for example, is an ambient exploration into colour. Bold and simple, Up To 625's plain pages of colour form a sharp contrast to anything else on the world wide web.

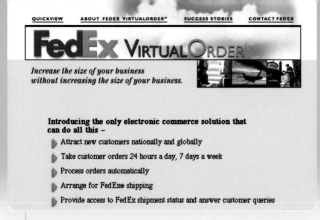

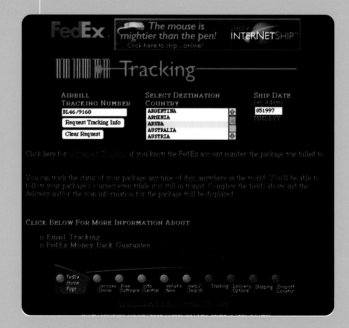

The FedEx site has function, design and purpose in all the right proportions. Moreover, its existence has already saved FedEx millions of dollars. Around 12,000 customers a day use the site as a means of tracking and locating their parcels, instead of asking a human operator to do it.

To track a parcel you have sent, simply select tracking from the express menu and fill in a brief questionnaire giving the parcel's airbill tracking number, the destination and the day it was sent. The status of the package can be checked at any time of the day from anywhere in the world. Users can follow the package even when it is in transit and can email questions about the shipment direct from the site.

FedEx has also launched InterNetShip from their site. The user inputs the details for the shipment they wish to send into a form online. Details of th[e] shipment are passed on direct to FedEx. The user can arrange for a courier to collect the package online, so not even a phone call is needed. This site was developed at Federal Express in Memphis, Tennessee.

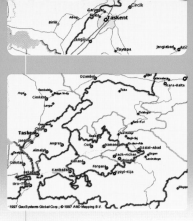

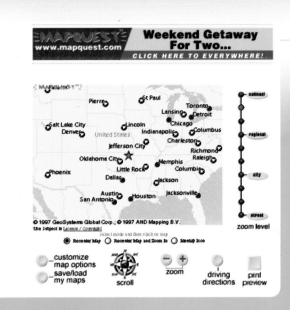

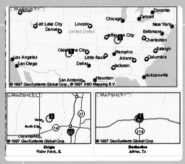

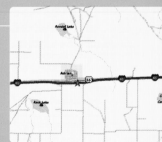

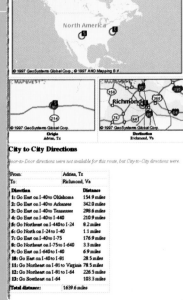

City to City Directions

Door-to-Door directions were not available for this route, but City-to-City directions were.

| From: | Adrian, Tx |
| To: | Richmond, Va |

Direction	Distance
1: Go East on I-40 to Oklahoma	154.9 miles
2: Go East on I-40 to Arkansas	342.0 miles
3: Go East on I-40 to Tennessee	298.6 miles
4: Go East on I-40 to I-440	210.9 miles
5: Go Northeast on I-440 to I-24	8.2 miles
6: Go North on I-24 to I-40	1.1 miles
7: Go East on I-40 to I-75	176.9 miles
8: Go Northeast on I-75 to I-640	3.3 miles
9: Go East on I-640 to I-40	6.9 miles
10: Go East on I-40 to I-81	28.5 miles
11: Go Northeast on I-81 to Virginia	78.5 miles
12: Go Northeast on I-81 to I-64	226.5 miles
13: Go Southeast on I-64	103.3 miles
Total distance:	**1639.6 miles**

Mapquest
www.mapquest.com

29

With Mapquest you need never be lost again – provided of course that you can access the internet. Mapquest is an interactive map of the world that allows the user to browse through a mind-boggling three million locations worldwide. The Interactive Atlas allows the user to search for a location almost anywhere in the world.

First select a country, then add the postcode and address of the location. With the Java Atlas, however, users can zoom in and out of locations; the personalized map utility has over 80 customized drag and drop icons. The Java Atlas is best viewed with Netscape 3.01 and Microsoft Internet Explorer 3.0. GeoSystems has compiled a digital map base of over 565,000 miles of road in 48 states of America.

They also have information on local parks, national sites and water bodies. Viewers can use Mapquest to customize information on their own map, adding landmarks and places of interest, and can copy the GIF image created on to the hard disk of their computer.

GeoSystems Global Corporation (US)

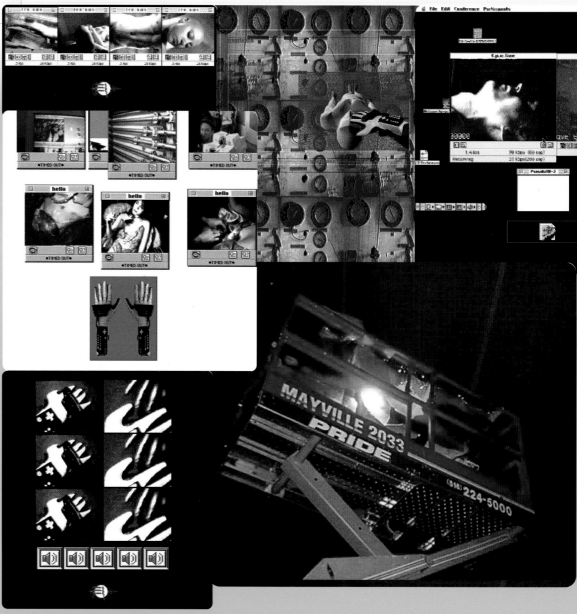

Floating Point Unit

www.thing.net/~floating/past2.html

Floating Point Unit (FPU) uses and addresses new media technologies with special emphasis on distance performance and internet broadcasting. Since 1991 the group has initiated a number of hybrid art projects in and around New York.

'The FPU Group is involved in the staging of media saturated installation events which combine digital/analogue electronics, inflatable structures the human body and video observation platforms.' To begin the FPU experience online you simply click on the floating bodies, which will then take you into one of the presentations.

Expect to be treated to a wide selection of interactive, film, photography, animation and sounds. The FPU site is a multi-layered, non-linear experience – you never know exactly what the next click of the mouse may bring or where it will take you.

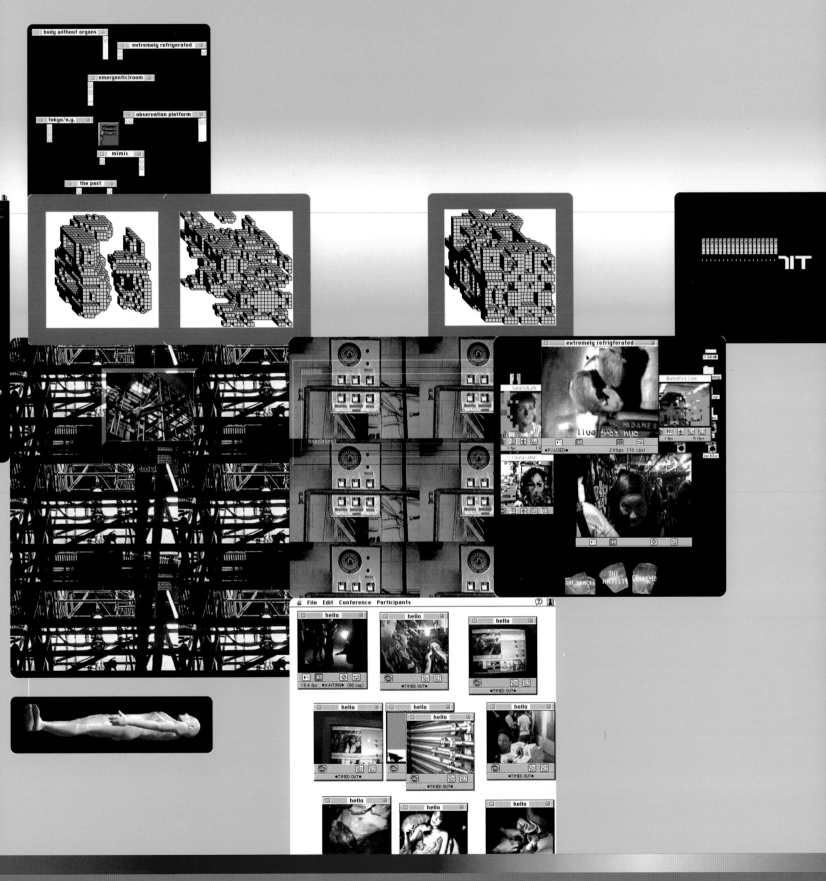

30

1X ◯ 2X ◯ 4X ◉ 8X ◯ Color ☒ Enhanced ☒ Brighter ☐ GIF image ☐

Live Cameras on the Net

//cyber-space.net/live.html

Bringing the real world online has always held a fascination for internet designers. This site provides access to many of the live camera links online. However, what people choose to film and beam around the world is regrettably out of the hands of the user. Some sites have been critically acclaimed, like the legendary Fish Cam.

One of the longest residents in the Netscape's What's Cool site, the Fish Cam is the second oldest live camera site on the internet and receives an amazing 90,000 hits a day. See the fish swim around in their tank and have your own soothing virtual aquarium. Well almost. The reality for most users will be viewing a still image, which then painfully reloads with the fish in slightly different positions.

The Trojan Coffee Machine at Cambridge University, England, the first live camera site, has been another great success. More interesting are the cameras located in different cities, where unsuspecting members of the public are the stars.

Josh Feldman of Prophet Communications, San Francisco, has made it his mission in life to promote alternative internet design. His work can be accessed from the Prophet Communications homepage, Spectacle. Feldman's Dreamstate site is his vision for storytelling in a digital age. Feldman has moved away from the confines of the static printed page, using both the words and type to convey a story.

The sentences are animated and flash up on screen without any interaction. All the user has to do is sit back and enjoy. Dreamstate actually began as an experiment to see if it was possible to create a movie without actors. With his Iconoclast site Feldman 'wanted to see what I would come up with if I had the chance to design a website with no constrictions. I'm pleased with the result.'

The Iconoclast is a richly textured site which also houses Feldman's collection of weird and wonderful internet links.

ALICE (Artificial Linguistic Internet Computer Entity) is an artificial intelligence server designed to hold natural language conversations with clients on the Internet, and to provide them with an interface to a humanoid telerobotic camera.

YOU SAY:

Hello Alice

[Reply to:]

ALICE

I have my own dislikes and likes. You don't need to tell me what I like. Do you like ADRIAN ?
ADRIAN

YOU SAY:

This response bears no relation to the information I gave regarding my name

[Reply to:]

ALICE

ADRIAN : I have set the TOPIC to WHAT THE IMAGE DEPICTS IT .

YOU SAY:

The image seems a little low on detail. Can you improve it?

[Reply to:]

Yes of course I THE CAMERA . ADRIAN , My THE CAMERA ? Can you MOVE .

YOU SAY:

Alice, you're not making sense.

[Reply to:]

ALICE

ADRIAN : I moved the robot for you

YOU SAY:

Wow, that was excellent the view's completely different now.

[Reply to:]

ALICE

These are the investments often recommended by ALICE clients ("the ALICE portfolio"): Intel, Microsoft, Apple, and REAL ESTATE.

YOU SAY:

If you can't show me an intelligible image, could you describe what I'm miss

ADRIAN : I moved the robot for you

YOU SAY:

Would it be possible to focus the image?

[Reply to:]

ALICE

ADRIAN : How long have you been OFF ?

YOU SAY:

Loony .

ALICE, or Artificial Linguistic Computer Entity, is an artificial intelligence server designed to hold natural language conversations on the internet. Talking to a computer is simple: fill in the box marked 'you say' and then hit 'reply to ALICE'. Keep it simple – she does get confused if you ask her the meaning of life.

First activated in November 1995, ALICE runs on a network of computers in the robotics lab at Lehigh University, Bethlehem, Pennsylvania. The primary web server and A1 program are on a Sparc-20 server, but large proportions of her telerobotic functionality are scattered across the network.

ALICE is designed to confuse the user, the idea being that if you get too involved in a chat, you start to forget she is a computer. In the future her creators would like to see humans replying to questions ALICE asks them.

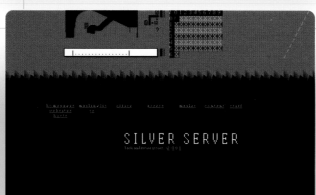

Silver Server

www.silverserver.co.at

The Silver Server is an important site for the people of Vienna, and indeed for the internet community in general. Silver Server is helping to pioneer non-commercial art on the internet – a refreshing change and also important for the future of the online community.

It is providing young artists and designers with a new medium in which to show their work to a worldwide audience. Silver Server provides cheap, fast access to the internet for the people of Vienna and free connection for non-commercial projects.

Silver Server is one of three founders of the Vienna Backbone Service, which builds nodes all over the city and provides faster and cheaper access than any other provider. This means they have a bit of bother from the Austrian Telecom service.

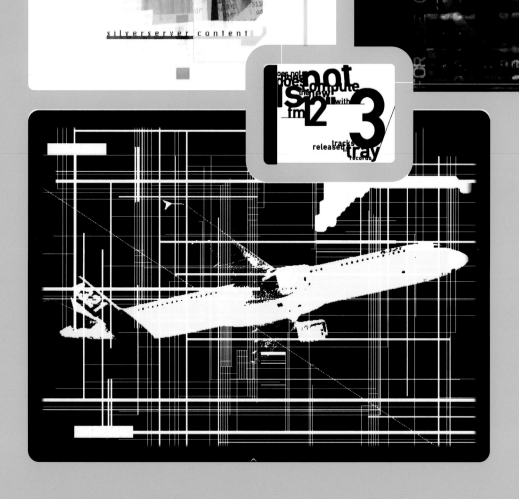

silverserver content

not is 12 3
tray

34

Chicago-based type foundry T-26 plans to always have its site under construction. Lots of plug-ins are needed to the view the site which works best with Netscape 3.0 or later. For best results users need Shockwave/Flash, QuickTime and QuickTime VR. T-26 offers over 290 typefaces from well over 100 designers.

The website is an excellent way of browsing such an extensive catalogue and each page is beautifully illustrated. A tool bar at the top of the site presents the user with a variety of ways to conduct a search: by name, designer, kit or style. A panel on the left-hand side acts as an index of contents. It is hard to get lost in a site as well organized as this one.

To complete the experience, it is also possible to order fonts from the site. Apart from the fonts, users can find information on the company's record label, Thickface, and other merchandise, and of course a company profile.

ABCDEFGHIJKLM
NOPQRSTUVWXYZ
abcdefghijklmnopqr
stuvwxyz1234567890
[[([¢9™£/@#$%^₤*]]]

euphoric medium•designed by basford+glover•6 weights•59$

issue nine

reverb™

reverse edits and forward thinking

nine for your twelve-hundred

premieres:

now
playing:

held
over:

Metamatics: EP01
(Clear - Limited run)

back catalog

Save "reverb08.pdf"
48% of 856K (at 1.4K/sec, 05:25 remaining)
Will open with "Adobe Photoshop™ 3.0".
Cancel

Reverb
www.reverb.com

36

Reverb is an internet music magazine based in Chicago which concentrates on the Detroit House scene. As Chicago is the birthplace of techno, Reverb is ideally positioned to keep anyone with an interest in the scene up-to-date with the moves and grooves. Though it was founded in 1993, Reverb closed down for two years.

Of the demise of his magazine, editor and creator Dan Sicko wrote: 'multimedia projects are a bitch to keep going by yourself, especially ones that purport to keep in step with something as fluid as dance music'. Hence, on relaunching the title, Sicko hired a creative director, Matt MacQueen. Each month Reverb publishes reviews of new record releases and white labels and clubs.

The advantage Reverb has over a standard music magazine is that small AIF sound files can be downloaded with samples from each record.

Editor-in-chief: Dan Sicko
Creative director: Matt MacQueen
Created by Dan Sicko, Chicago

HYPERREAL

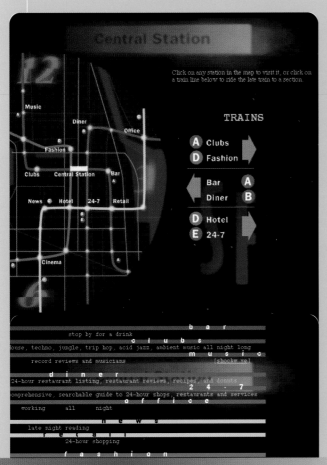

Hyperreal is a collaborative publishing effort by over 100 volunteers. Their mission is to create a home for alternative culture, music and expression. Hyperreal contains information about other electronic publications, drugs, plus a useful library of sound and graphics tools and links. Hyperreal was founded in 1992 by Brian Behlendorf.

It started out as an email-based mailing list focused on the San Francisco rave scene. Behlendorf was given access to a spare Sun Sparc 1. 'I decided it would be cool to set up an archive of information related to my mailing list. I started scanning in flyers and I digitized some of the music.' Thus Hyperreal was born.

It linked itself to other similar mailing lists such as The Intelligent Dance music list. In 1993 the server had to be given back, so Behlendorf obtained permission from *Wired* magazine to run his site from its server (he was maintaining their server at the time). Hyperreal now resides at Organic, a company founded by Behlendorf.

You Don't Know Jack

www.bezerk.com/htmls/tuner.html

Founded in 1987, Berkeley Systems Inc. develops and markets multimedia entertainment software for an adult market. After the success of its AfterDark Screensaver franchise Berkeley Systems developed a second one to launch its pop culture trivia game, 'You Don't Know Jack'. This Mac/PC CD-Rom game proved a huge success so Berkeley Systems decided to put it online. 'You Don't Know Jack: The Netshow' is proving just as popular.

Housed at the beZerk Online Entertainment Network, the homepage offers two different game shows: general knowledge and sport. There are generous prizes on offer every week courtesy of You Don't Know Jack's sponsors. These include 7Up, Cuervo Tequila and Yahoo. The online version comes complete with the RealAudio effects and irreverent humour that made the CD-Rom game so popular.

In case you cannot get enough of Jack, new episodes are available twice a week. There are plenty of plans in the pipeline for the beZerk Network: over the next year they will launch sitcoms and soap operas online.

Design: Addis Group
Director: Nick Rush

Round 2

do you know JACK?

So what is YOU DON'T KNOW JACK the netshow?

YOU DON'T KNOW JACK the netshow is the online version of the award-winning, irreverent pop-culture quiz show party game now showing on be2erk.

The netshow is no webpage! Complete with real studio audio effects, seamless game play and wisecracking humor just like the CD-ROM game, now with new episodes available twice a week. The questions are hilarious combinations of pop-culture with classic trivia all as challenging as they are entertaining. It's time to put your knowledge to the test and your ego on the line, online that is.

Can't get enough JACK?

Get one of these cool new CD-ROM JACK games.

Get to KNOW JACK by selecting a product below

it's time for a

FLICKERPISS NOSESCUM

1 Are We There Yet?

2 Cat Scan

3 Do You Have "ESP"?

prizes!

may

Monthly Prizes | Weekly Prizes | Play Today and WIN | Official Rules |

With the month of May comes summertime just around the corner, so its time to get outdoors. JACK the netshow will await you the opportunities to get off your duffs and win some cool prizes to enjoy outside.

New this month, Weekly Prizes. There are no Daily Prizes during May but see what GREAT weekly prizes you can win. And, don't forget mom, play on May 7th to win her heart.

MAY 1997 DAILY PRIZES

WEEKLY PRIZES

mom

Mountain Bike

Golf Driver

Inline Skates

Tennis Rackets

may grand prize: double JACK attack for $5000 Details Below

question

I'd Like to Teach the World To Do the Hustle

$2,000

five

GIBBERISH QUESTION

Avast, Ya Scurvy Dogs!

$5,000

question

thirteen

FINAL SCORES

I'd Like to Teach the World To Do the Hustle $2,000

Shaking your booty is great, but it's pretty small scale. If you REALLY wanted to be bold and shake "Djibouti," what would you be doing?

1. gyrating East Africa
2. vibrating Central America
3. jiggling Southeast Asia
4. pumping Micronesia

Talbot
$8,000

Talbot $20,000

The Boys of Summer Eat Their Words

GIBBERISH QUESTION
prepare to rhyme

$10,000

Talbot
$16,000

Little Pricks $4,000

Imagine a sequel in which the scientists must reach the patient's heart. Assuming the voyagers go with the flow of the blood stream, which path should they take?

1. artery
2. vein
3. capillary
4. corpuscle

Talbot
$18,000

Come back soon!

The Boys of Summer Eat Their Words

A batter may grieve spring boast.

GIBBERISH QUESTION

The Saturday Evening Post™

V2 Organization

www.v2.nl

This site is available in both English and Dutch. The homepage is a graphical interface with different buttons that draw you deeper into the site, while also representing its structure. The homepage explains that V2 is split into three separate sections: V2 Archive and the V2 Organization have their own interface and pages. The third V2 av is only accessible through the main V2 homepage.

V2 was established in 1987. It launched with a manifesto entitled 'The Unstable Manifesto': 'We strive for constant change for mobility. We make use of unstable media, that is all media that makes use of electronic waves and frequencies.' The V2 site catalogues the relationships between developments in the field of technology and contemporary arts.

V2's page of links would impress anyone with a passing interest in creativity online – the choices are mind-boggling. The subjects covered by V2 are Architecture, Art, Magazines, Literature and finally Music.

V2 Organization, Rotterdam

DISSECTING TABLE

BETWEEN LIFE AND DEATH

Peter Duimelinks
1. Nulla Di Nuovo Sotto Il Sole
2. Colour Flicker
3. Desiderio In Rovina

V2 Archief V219

V2 Archief Postbus 11007

Frans de Waard
4. SurfaCe
5. Alles

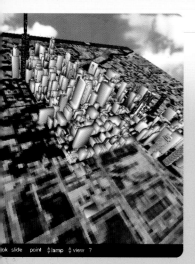

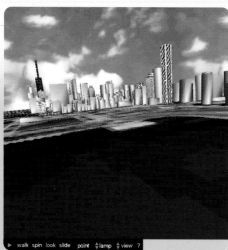

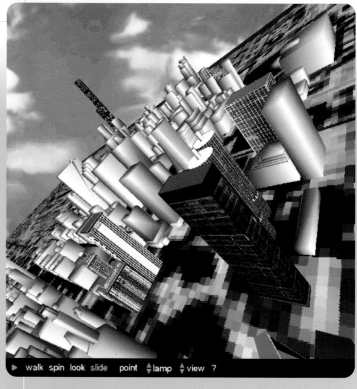

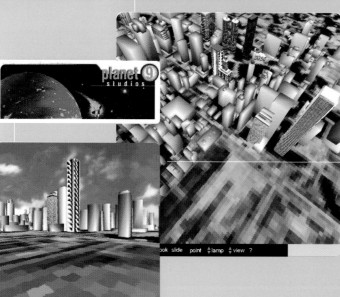

Planet 9 Studios

www.planet9.com

The greatest challenge facing all creators of commercial websites is how to find a way of actually making a living out of it. David Colleen of Planet 9 studios believes he can do just that with his virtual cities. Colleen is an architect who has taken to building in cyberspace. He works in VRML (Virtual Reality Mark-up Language).

So far he has put up virtual versions of San Francisco, New Orleans, New York, San Diego, Austin and Denver. Recently he branched out by beginning virtual London. These 3D computer-generated models allow the user to walk around the city, visit companies, shops and art galleries, even communicate with some of the residents.

Colleen's first world went online in February 1995 and was a model of San Francisco's SOMA district. Now to the money-making bit. Businesses can pay to have their buildings activated, giving details of their activities and providing a link to their homepage.

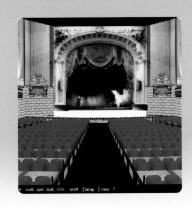

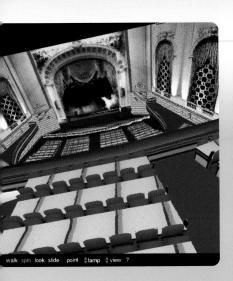

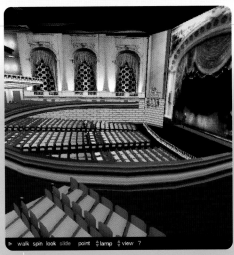

SonicNet
www.sonicnet.com

SonicNet is a fully comprehensive online music magazine which describes itself as 'a record store where you just click and get'. On SonicNet users can have conversations with some of the most influential people in the music industry. There are reports on concerts from around the world and the latest record releases, plus live concerts and sound samples of unreleased tracks. Although the site is enormous, there is a comprehensive map to guide you through.

The most exciting part of the site is Cybercast. Here SonicNet broadcasts live concerts online. There is a list of up-and-coming gigs. Some of the broadcasts are preserved on the site – The Beastie Boys and The Fugees, to name but two. The Listening Parties form a second branch of the Cybercast site. Every week unreleased albums are presented live online – users can hear the whole thing before it hits the shops. The Cybercasts are presented using RealAudio software.

SonicNet houses these broadcasts in a huge archive which can be accessed at any time. This makes SonicNet one of the biggest producers of online audio in the world.

Editor-in-chief: Nicholas Butterworth
Design director: Ofer Cohen

TechnoSphere

Creature Designer V.2	Creature Tools	Information	Links

TechnoSphere is being developed with support from:

THE ARTS COUNCIL OF ENGLAND	film and video umbrella	Cambridge Darkroom Gallery	Digital Workshop Ltd

Perhaps you would like to visit the Cyborg?

techno@lcpdt.linst.ac.uk

Information

New Information: Last Updated on 25.2.97

General information	TechnoSphere team
TechnoSphere system	Public presentations
Conference papers	Emails, images and VRML
Media coverage	Images & video
Toolbox	Artificial life stories

TechnoSphere

techno@lcpdt.linst.ac.uk

Herbivores

Use the forms below to select the head and body for your digital beastie. Click the circular selection button below the component of your choice.

HEADS

BODIES

WHEELS

EYES

We need your email address so that we can tag your creature with it. Your creature uses it to send you information, and you use this number to request information about the beastie, so make sure that you enter it correctly.

Please name your artificial life form:

Yannis

Please enter your E-mail address:

at@intro2.demon.co.uk

[Submit] [Erase]

Back to Creature Designer

TechnoSphere

"Yannis"
Herbivore ID 157866

"Yannis" was created by at@intro2.demon.co.uk and is 0.00 days old.
It is currently a CHILD and is 25.00 percent fit.
Its current activity is SLEEPING and its current action is SLEEP.
It has 0 children.
It has killed 0 creatures and had cyber-sex 0 times.
It has eaten 0.00 kgs of food, and has expended 0.05 kilocalories of energy,
and has moved a total of 0.00 kilometers.

Creature Location

"Yannis"
Herbivore ID 157866

➕ Specified Creature ➕ Carnivore ➕ Herbivore

Creat[ure]

Once you have designed a creature it will interact with the other beasties de... you of key events in its life. Use the ...

[Carn...]

The TechnoSphere was launched on 1 September 1995. Users can create a life form which lives, eats and breeds in a Fractal 3D environment. Before starting, users must choose whether their creature is going to be a carnivore or a herbivore. Once the critter's eating preferences are selected, the body can be put together. This is easy. There are four components that make up the body, eyes, head and wheels. There are five options for each and you select one by clicking on it.

Once this is done, your email address must be added (the creature needs this to email you information about its life). Once designed and tagged, it will be put in the Fractal 3D world, where it interacts with the other life forms present. At key moments in its evolution, it will email its creator. In addition to emails, an owner can receive 2D snapshots, check the location of their beast and download animations of the world.

The TechnoSphere is an 'experiment on a global scale. TechnoSphere is designed to encourage non-linear, experimental exploration.' It was created by Julian Sanderson, Andrew Kind, Jane Prophet, Gordon Shelley and Rycharde Hawkes.

Word

www.word.com

Funky New York webzine, The Word, succeeds in combining both style and content. If the web had more magazines like this one, the future of online publishing would be assured. The Word is designed to work best with the latest version of Netscape. It also requires Shockwave and RealAudio to get the best results.

The magazine contains irreverent and humorous articles which are added to on a daily basis. The main body of the site is divided into six sections: Place, Machine, Desire, Pay, Gigo and Habit. Each essay or article in every section of the magazine has a completely different style, making The Word diverse viewing.

Before exploring what each section has to offer a cover page appears which gives the sponsor details. Advertisers on The Word have moving-image ads.

Editor: Marisa Bowe

Golden Showers
by William Leith

SIGNS

photographs by Warren Neidich

Russian Prison Tattoos

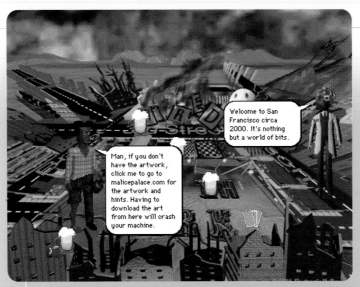

Malice Palace

www.malicepalace.com

Malice Palace aims to turn internet culture on its head and show how we can really have fun online. The site invites the user to 'come on in and experience virtual pain...come and be abused by robots with artificial intelligence'. Created by Jaime Levy and Steve Speer, it is a VR site. The user participates as an avatar. Malice Palace is set in San Francisco. The year is circa 2000 and in the post-technology industry backlash, net survivalists eat hippies and computer nerds for dinner.

The break beats of Jungle music hammer through the speakers courtesy of DJ Spooky, a contributor to the Palace. Before entering, the user must download the Rave Backpack, which contains the rooms, props and music. Some of the characters will help the user when clicked – the word 'hippy', for example, can be used to get a response from the hippy robot. The Mexican and leatherqueen robots will also give assistance. In all there are eight districts to explore.

Malice Palace is part of the Palace Group of virtual worlds, which originated at Time Warner when Mark Jeffery and Jim Bumgardner invented the software while working for Warner's Palace Group. Investors include Intel and Softbank. More than 1,000 Palace-driven sites exist.

Jewish Tit Print

news stuff

art

quiz

words

links

about annie

Penis Tit Print

Heart Tit Print

California Tit Print

Double Tit Print

Jewish Tit Print

Annie Sprinkle

www.heck.com/annie/
annieart.html

45

Annie Sprinkle is a pioneer. A feminist and a porn star, she spent years working as a prostitute in Manhattan and has appeared in countless porn movies. Sprinkle formed PONY, a charity committee working towards the decriminalization of prostitution. She also formed a body called PPSS, set up to encourage pornographers to use safe sex in films. Over 300 of her articles have appeared in publications ranging from porn mags to arts publications.

Her website is a reflection of her particular humour as a 'porn-post-modernist'. Most of the artwork from the site, such as the Tit Prints pictured above, is available in her regularly produced postcard books and catalogues. In the Sex Soup section, Sprinkle uses the Burroughs technique, creating poetry by cutting up words. But Sprinkle likes to mix really straight writing with porn, and the results are alarming. Equally alarming is her Public Cervix Announcement.

Here Sprinkle gives the online explorer a chanc examine her cervix. 'The cervix is a beautiful crea yet most people go through life without having seen one. Over the years I have given thousan people that opportunity with the aid of a specu and flashlight.' With these performances she he to assure the misinformed that the cervix has n teeth. See for yourself.

46

The Artificial Painter is a joint Italian and Danish research project between The Institute of Psychology, National Research Council, Rome and the Department of Computer Science, Arhus University, Denmark. The Artificial Painter (AP) software package uses a genetic algorithm on neural networks. The AP evolves pictures to be used in artistic design.

The evolution of pictures is based on the user's evaluation of a number of pictures shown on screen. If this sounds too 'techie' to take in, the interactive demo helps to illustrate how the paintings will reproduce themselves. The files are very low resolution as the project's creators were concerned with the speed of data transfer.

There is a whole gallery of proper Artificial Painter images available to be browsed. There is also a page of AVI and MPEG movies that reproduce the evolutionary processes of an image through different generations.

Programming: Henrik Hautop and Luigi Pagliarini

Holbein, Hans (1465?-1543)

Sir Richard Southwell
1536

Turner, Joseph Mallard William (1775-1851)

Snowstorm
1842

Caravaggio, Michelangelo Merisi de (1573-1610)

The Inspiration of Saint Matthew
1602

http://www.southern.net/wm/paint/auth/holbein/southwell.jpg

Back
Forward

Open this Image
Save this Image as...
Copy this Image
Copy this Image Location
Load this Image

WebMuseum, Paris

Netscape: JPEG image 731x1177 pixels

Back | Forward | Home | Reload | Images | Open | Print | Find | Stop

http://www.southern.net/wm/paint/auth/caravaggio/matthew.jpg

WebMuseum

www.oir.ucf.edu/wm

The WebMuseum's network is expanding fast. Hundreds of artists, works of art and art movements are recorded online. There are over 200,000 visitors to this site every week. Partners of the WebMuseum are Netscape and the Encyclopedia Britannica. The network is spread all over the world. Switching to the nearest service provider will dramatically speed up data access.

The brain-child of Nicolas Pioch, the WebMuseum was not made as part of any official project. There was no grant behind it. Pioch simply decided that there was not enough art on the internet. The WebMuseum has been taking up his weekends and spare time since spring 1994. This is Pioch's stand against companies who are trying to make 'a monopolistic grab on the arts and culture,

developing pay per view logic, shipping out CD-Roms while trying to patent stuff which belongs to us, a part of our civilization and history. With no support, no funding, no manpower, the WebMuseum is a collaborative work of its visitors and founder.

Van Gogh, Vincent (1853-1890)

The Vase with 12 Sunflowers

Mondrian, Piet (1872-1944)

Composition with Red, Yellow and Blue
1921

Hockney, David (1937-)

A Bigger Splash
1967

Pollock, Jackson (1912-1956)

Number 8 (detail)
1949

http://www.southern.net/wm/paint/auth/gogh/sl/gogh.12-sunflowers.jpg

http://www.southern.net/wm/paint/auth/pollock/pollock.number-8.jpg

47

Entropy8

www.entropy8.com

Created by Auriea Harvey, Entropy8 is a wonderfully textured site, rich in colour. Her organic imagery serves as a real contrast to the clean digital imagery of the internet. Even though it does take some time to fully load each page, it is certainly worth waiting for the diverse illustrations, sounds and animations.

The control panels to access content for the site do not appear as part of the page, within the frame of a browser. Instead they appear as a separate panel. This can be moved to any position on the desktop. Instead of the usual list of content or slick buttons, Harvey uses a still frame from each site.

Entropy8 is a highly personal site. Harvey describes her work as 'a personal goal in a public space'. Her family's early years before she was born are explored, and she keeps an online diary called The Disease Manifesto, where her hopes, frustrations and inspirations are recorded.

48

Clifford A. Pickover

//sprott.physics.wisc.edu/pickover/home.htm

Clifford A. Pickover received his PhD from Yale University's department of Molecular Biophysics and Biochemistry, graduating first in his class. His homepage brings together his love of science with his love of art. 'My primary interest is in finding new ways to continually expand creativity by melding art and science, mathematics and other seemingly disparate areas of human endeavour. I seek not only to expand the mind but to shatter it.'

His homepage includes computer art, puzzles, fractals, alien creatures, black hole artwork and animations supported by Java and VRML. Pictured above are a selection of virtual sea shells from the Explore Virtual Reality Zoology with VRML section. The Wishing Project explores the human fascination with wish fulfilment. Download a Wishing Stone, place your wish in a catalogue of wishes from different cultures, and see how they compare.

In My Virtual Cavern the user can view an experiment of water rippling in a cavern of virtual stalagmites and stalactites. The Java applet computes the rippe to the user's screen in real time. The Alien Chambe houses discussions on alien life forms and invites the user to submit their own drawing of a life forr Some will be included in Pickover's next book. He posts the best drawing received each week on his site.

49

Clifford A. Pickover

//sprott.physics.wisc.edu/pickover/home.htm

The Digital City is an online version of Amsterdam. All the data anyone could ever wish to access about the city of Amsterdam is housed here, and thousands of the city's inhabitants have their own homepage. As a result, the site registers millions of hits every year.

Putting across such a lot of information could easily get confusing, but the Digital City site manages to handle the data with the use of simple and intuitive icons, so navigating the site could not be easier. Constant icons are present around the main window, whichever section you are in.

The café icon, a wine glass, allows users to chat with other people viewing the same page. The tax icon will take users to relevant links, while the envelope sends mail. There is a section where personal ads can be placed and one that tells use who is online.

Welcome Talbot to Nexsite
View your personality capsule

Find

nexsite
ww0.nexsite.nttdata.
/main/menu.jhtml

51

Wouldn't it be great it we could all help to create a better society on the internet? That is what the NTT Data Corporation hopes to do with Nexsite. Nexsite is powered by 'Dynamo, the most sophisticated application available on the web today'. On every Nexsite page you visit, Dynamo lets you know who is online and what they are doing the moment you view the page. Dynamo is an application server written entirely in Java.

Additionally, Nexsite employs seven Sun Sparc Ultra 1 servers, each running a Dynamo engine. These servers coordinate through a central Object Oriented Database, also written in Java, which ensures that all Nexsite users participate in a single, seamless community. It is easy to create an individual or group capsule to interact with other users.

Then users can take part in World Fiction, a shared real time environment, where users contribute to an online comic strip – each entry extends the world. Later this year Nexsite will launch Brain Opera, an interactive music performance that uses networks created by Professor Todd Machover at the MIT Media Lab. Check out Nexsite's What's New section for further details.

Form

www.c3.hu/hyper3/form

Form is a project created by Alexei Shulgin, in which he proposes a new art form: 'Form Art'. The new art is based around internet technology and Shulgin hopes it will give artists new possibilities of self-expression. The website consists of numerous Form Art images and other examples of Form Art implementations.

The Form Art images are made up of text boxes, which the user can type in, and scroll boxes. Essentially Form Art is an example of how the internet will affect the future of art. Form Art works only on a computer – there it was created and there it must be seen. User interactivity is integral.

Undoubtedly many, many more art forms will develop from online exploration. In the mean time the Form Art website is open for contributions and discussion. The project is being produced in cooperation with C3, Budapest.

text only

C³

S
SCCA
Budapest

Si
Silicon Lab

T
Technical
Page

In
Info

M
Magyar

Se
Search

G
Grants

Ex
Exploration
Lab

H
Hyper 3

N
NGO sites

I
Internet Lab

O
Open Lab

R
Resource
Lab

Pa
Past

F
Future

L
Links

P
panananie

Sf
Soros
Foundation

Form beta 1.

THANKS

52

HotWired Han Solo Design Contest.

Where do good ideas come from?

Talk to the
doctor on call healthy ideas

June 06, 1997

[ask Dr. Weil

Spooked by SPAM?

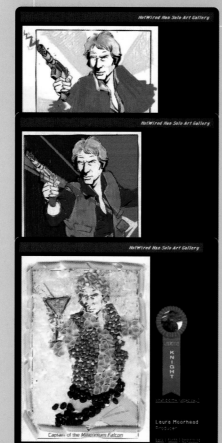

HotWired Han Solo Art Gallery

HotWired Han Solo Art Gallery

HotWired Han Solo Art Gallery

Laura Moorhead
Producer

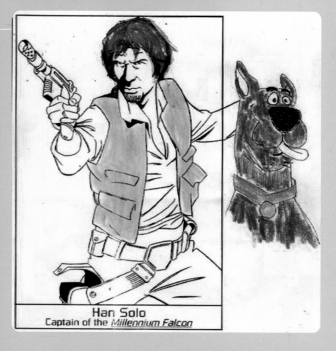

Han Solo
Captain of the *Millennium Falcon*

HotWired

www.hotwired.com

HotWired is one of the most popular sites on the internet. Created by the US technology magazine *Wired*, HotWired is essential reading for all those partaking in internet culture. Continually updated, it provides an eclectic mixture of news and views on electronic culture. HotWired works best if the user signs up to the HotWired network (this is free).

The member name and password allow the user to tailor the features to suit their preferences and browser. It also means that it is possible to take part in real time chat with other members. The subscriber can also choose to have news delivered directly to them.

This is done in a variety of ways. Those who use Netscape to open their email can have Wired news delivered to them every day. The Point Cast system is more advanced. This provides cheap, up-to-the-minute personalized news broadcast to their screen over the Point Cast Network. HotWired also has the presence of mind to provide its own internet search engine, Hot Bot.

Share Your Experiences

Broome

Share your experiences with fellow travelers. Add your tips, gripes, dodges, and kudos below. Note: You must be a member to add your comments. Not a member? **Join** now.

Name:

Title of post:

Comments:

Seb: realaudio 28.8 or ISDN

next

Join the HotWired Network, it's free. Members: log in

The Rough Guide

Savvy. Sensible. Sophisticated.

help search

into usa into europe into canada

into australia into mexico into hong kong

into india

realaudio 28.8 or ISDN

remix

The Rough Guide

home help search go to book

India basics

home help

australia basics

How hot is too hot? Curries and more, in Threads.

In love with Vegemit...

SEARCH
HELP

Copyright © 1994, 1995, 1996, reserved.

Copyright © 1995, 1996, 1997 HC reserved.

SEARCH
HELP

Seb and Pongoid: realaudio 28.8 or ISDN

next

Join the HotWired Network, it's free. Members log in

The Rough Guide

Ladakh

home help search go to book

India Leh into cities

into regions

basics

SEARCH

next live event: 12 June 1997

PORT: navigating digital culture

MIT List Visual Arts Center
January 25 – March 29, 1997

Public opening reception
Friday, January 24, 5:30 to 9:30 pm

http://artnetweb.com/port/

artnetweb

Slide Registry

The **Slide Registry** is a fast and inexpensive way for you to get your art on the Web. Imagine a collector or curator half-way around the world being able to view your work from the comfort of their living room, and then contacting you directly...no galleries, no dealers or agents. That's direct access. Not a bad deal for web surfers either.

Begin Browsing . or . See List of Artists

Request Entry Information .. How to Navigate this Section

(high) index (low)

help feedback

Copyright ©1995 artnetweb, http://artnetweb.com/artnetweb

← previous title page inquiries next →

5 Vases, steel, 4'x 25'x 25', 1993 ©

Copyright ©1995 artnetweb, http://artnetweb.com

Artnetweb

Artnetweb operates like a conventional art gallery. Most of the artwork on the site is curated. Artnetweb commission artists who show 'an understanding of the web's creative potential' to create online installations. In The Gallery District galleries put their current exhibitions online, enabling clients to view work for sale at any time anywhere in the world.

The site manages to keep abreast of new technology while remaining straightforward and easy to navigate. This enables Artnetweb to show the work without distraction to the user. Based in New York, Artnetweb was founded by Remo Campopiano and Robin Murphy. The website is 'the third phase of a process to establish an art colony in cyberspace'.

The other parts are: The Internet Reading Room, a shop in Soho, New York, where artists, or indeed anyone, can drop in to find out about the internet and how to get online; and the BBS, a dial-up bulletin board.

Medium: Oil, acrylic, wax, silk-screen paper, & photograph collage
Collection of the Tokyo Metropolitan Museum of Photography
← *previous* *title page* *inquiries* *next* →

Abstract #50619; Date June 19, 1995; Size 8x10" (11x14 frame);
Medium: Oil, acrylic, wax, & silk-screen paper, collage; $ 350
← *previous* *title page* *inquiries* *next* →

Abstract #50523; Date May 23, 1995; Size 8x10" (11x14 frame);
Medium: Oil, acrylic, wax, silk-screen paper, & photograph collage; $ 350
← *previous* *title page* *inquiries* *next* →

Abstract #50703; Date July 3, 1995; Size 11x14" (16x20 frame);

Levi's

www.levi.com

Levi.com is a great illustration of what can be achieved with a brand online. Levi.com is one of the most comprehensive branded sites on the internet. This is partly due to its colourful and historic heritage and the fact that Levi Strauss is a global brand. Two choices await the user on alighting on the Levi's homepage: Europe or America. Clicking on the location you are in will provide specially tailored editorial, such as the nearest Levi's store.

Once the choice has been made it is possible to enter the site proper. There are three main sections: Heritage contains details of the brand's history; Living Denim, the lifestyle section; and finally, The Ads. Here Levi Strauss actually succeeds in making its commercials fun to watch online. There is a site map for those with a poor sense of direction, though navigating the site has been made extremely simple.

Click on the Levi's Red Tab or rivet icon to go back home. The site contains audio files in RealAudio format, Shockwave and QuickTime movies multi-player games and competitions. The most recent versions of Netscape and Explorer are recommended

Design: Obsolete, London and
TN Technologies, San Francisco

TO THE DEPTHS OF PASSION

[JEAN·EOLOGY]

LEVI'S

OLDEST KNOWN JACKET

DENIM DICTIONARY

History. His-story. Her-story. Our-story. It's the HERITAGE of Levi Strauss & Co. and it's all here. Travel through our Jean-eology, a telling display of unique letters, ads, sound bites and tall tales that we've collected over the years. Then inform yourself in the Denim Dictionary, an information journey from A to XX. And be sure to see the Oldest Known Jacket in the USA and find out how it came to find us.

1853

It all begins. Levi Strauss sails from New York City to San Francisco, California. Once there, he sells everything from tablecloths to sewing needles.

1906

The Big One, a major earthquake hits San Francisco and we lose just about everything. See the destruction and read the outrageous

enter the Wide World of Levi's® Wide Leg Jeans.

IT'S WL

how wide do you wear them?

With the wide selection of Levi's® Wide Leg Jeans, there's a fit that's right for you.

TV Commercials. How wide do you watch them?

Have an Elevator Fantasy
Open wide for the Doctors

How wide is your screen?

Download Screensaver

ONE COUPLE'S DESCENT

ABCDEFGHIJKLMNOPQ
Heritage De

DENIM DICTI

"everything yo you wanted to k about Levi's

© Levi Strauss & Co. 1996, 1997. All rights re

[JEAN·EOLOGY]

LEVI'S

Next History Eve

1936

LEVI'S
LOOK FOR THE RED TAB

The Tab Trademark Is Born.

There had to be a better way than staring long and hard at a person's rear to tell if they were wearing real Levi's® jeans or not. That better way came in 1936. The idea was simple. Put a little flag on every pair and then with a quick glance you could see who was a real original. It's called the Tab Trademark and, for you trivia fans, impress your friends with this little factoid; every seventh pair of Levi's® jeans comes with a Tab Trademark that's blank. It doesn't say Levi's® on it. It's not a mistake, it's one of the ways we protect our legal rights to the Tab Trademark. It's the least we can do since it's served us so well for so long.

1853 | 1906 | 1936 | 1942 | 1948 | 1969 | 1974 | 1980 | 1991 | 1995

WOMAN'S WIDE WORLD

WL

501

Work the Wideness.

Start with cursor to the left, then using the original Levi's® 501® and 512™ Jeans as reference, go Wide right and see what opens up.

TO THE LOBBY

ABCDEFGHIJKLMNOPQ
Heritage De

P. POP/POS:

A Point of Purchase / Point of Sale materials are placed in the retail store either on a rack of clothing or on a sales counter in order to help customers find the right pair of Levi's® jeans.

Pre-1971 Levi's® Jea

If your Levi's® jeans have a ca TAB DEVICE, they were made be considered a valuable collector purists.

IT'S ELEVATOR FANTASY

[JEAN·EOLOGY]

LEVI'S

Next History Eve

1974

Man Hangs by the Seat of His Pants... Sort of.

Believe it or not, this is only one of many letters that we've gotten telling us how our Levi's® jeans or other products have saved lives. Read the actual three-page letter and at the bottom of its first page download a sound file which recounts the events of that day in 1974 that turned a Levi's® shirt into a Levi's® lifesaver. We checked with eyewitnesses and yes indeed, this really happened...

THANK GOODNESS FOR MY LEVI'S SHIRT!

WOMAN'S WIDE WORLD

WL

WIDE
SilverTab

Work the Wideness.

Start with cursor to the left, then using the original Levi's® 501® and 512™ Jeans as reference, go Wide right and see what opens up.

DIRECTED BY MICHAEL BAY

Index of /

Name	Last modified	Size
readme.txt	30-Apr-97 11:28	4k
cars/	14-May-97 21:45	
cctv/	16-Mar-97 13:40	
cern/	24-Apr-97 13:35	
competitions/	01-May-97 08:09	
cybercafe/	06-Dec-96 15:46	
disinformation/	01-May-97 06:23	
fresh.html	15-May-97 19:05	4505
guides/	01-May-97 08:28	
information/	27-May-97 12:19	
interact/	14-May-97 20:26	
internal/	27-May-97 14:15	
junk/	16-Apr-97 14:21	
pleasur/	30-Apr-97 12:03	
rachel/	02-May-97 18:21	
random/	28-May-97 13:10	
sic/	26-Mar-97 08:46	
skint/	10-Dec-96 14:32	
tags/	30-Apr-97 12:08	
ta/	15-May-97 13:42	
x/	02-May-97 10:38	

Index of /guides/

Name	Last modified	Size
Parent directory		
london/	16-May-97 15:43	
palm/	01-May-97 08:28	
velocity/	15-May-97 14:31	

3 files

Irational

www.irational.org

Internet artist Heath Bunting is the secretive creator of the Irational site. He has no set rules governing his creation. He updates the site when he feels like it and will not say where he is based (for the record, it is London). His homepage is a simple list of hot links entitled Index.

Its simplicity cleverly hides what is to come. If users start at the top of the list and open the 'read me' text, they will simply get 'welcome to irational. org.' Bunting includes the work of other artists and organizations on his site, but the best bits are his own. For example, the excellent Junk Mail: 'Prefer not to

get junk mail?', Bunting asks, 'Then what about re-directing it?' The name and address of a junk mail company appears below this for the user to redirect their mail. There is much more to enjoy at Irational. Pictured above are images from Bunting's extensive Index of London.

Index of /guides/london/

Name	Last modified	Size
Parent directory		
readme.txt	01-May-97 08:31	329
acceptance.gif	02-Aug-95 13:51	1265
acceptance.html	17-Oct-95 07:40	94
acceptance.map	02-Aug-95 13:51	246
accident.gif	02-Aug-95 13:51	7547
accident.html	17-Oct-95 07:40	90
accident.map	02-Aug-95 13:51	284
actonslock.gif	02-Aug-95 13:51	7886
actonslock.html	17-Oct-95 07:40	94
actonslock.map	02-Aug-95 13:52	166
advertised.gif	02-Aug-95 13:52	1347
advertised.html	17-Oct-95 07:40	94
advertised.map	02-Aug-95 13:52	348
afraid.gif	02-Aug-95 13:52	1102
afraid.html	17-Oct-95 07:40	86
afraid.map	02-Aug-95 13:52	253
aldgate.gif	02-Aug-95 13:52	9901
aldgate.html	17-Oct-95 07:40	88
aldgate.map	02-Aug-95 13:52	300
alphgate.gif	02-Aug-95 13:52	7359
alphgate.html	17-Oct-95 07:40	90
alphgate.map	02-Aug-95 13:52	248
anger.gif	02-Aug-95 13:52	1176
anger.html	17-Oct-95 07:40	84
anger.map	02-Aug-95 13:52	206
archwayviaduct.gif	02-Aug-95 13:53	5506
archwayviaduct.html	17-Oct-95 07:40	102
archwayviaduct.map	02-Aug-95 13:53	262
art.gif	02-Aug-95 13:53	986
art.html	17-Oct-95 07:40	80
art.map	02-Aug-95 13:53	225
artec.gif	02-Aug-95 13:53	9247
artec.html	17-Oct-95 07:40	84
artec.map	02-Aug-95 13:53	245
audience.gif	02-Aug-95 13:54	1092
audience.html	17-Oct-95 07:40	90
audience.map	02-Aug-95 13:54	201
author.gif	02-Aug-95 13:54	1115
author.html	17-Oct-95 07:40	86
author.map	02-Aug-95 13:54	241
authority.gif	02-Aug-95 13:54	1213
authority.html	17-Oct-95 07:40	92
authority.map	02-Aug-95 13:54	246

`<..+(con)(fuse)d-..>`

MOST ART SAYS NOTHING TO MOST PEOPLE

Day-Dream

www.day-dream.com/007/007.html

The Day-Dream site is, in the words of its creators, Thinking Pictures New York, 'a rest area of the information superhighway'. It certainly achieves its purpose, existing as art for art's sake. At the same time the site is inventive and absorbing.

Trippy, animated graphics and small director movies entertain and soothe away the frustrations of the internet, while creating a visual feast. With very little text and no advertising there is nothing to concentrate on; the contents would make excellent screensaver material.

Day-Dream is regularly updated and works a bit like a magazine, as it is released in issues. All of the previous issues can be accessed from the site.

57

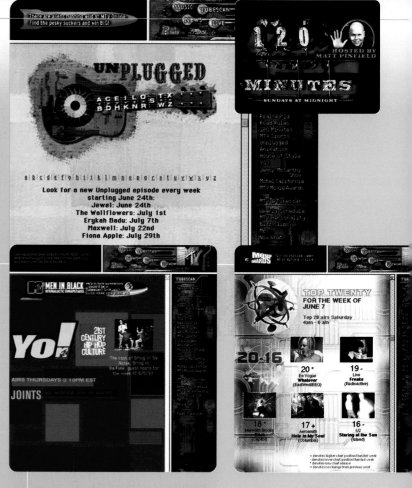

Cable music channel MTV offers the user two points of entry to its site. Decaf for those without Java, and Java for those with a Java-enabled browser. While waiting for the Java script to load, MTV wastes no time serving information – giving the latest news stories. The control panel running across the top of the screen can be formatted to float as an unsigned Java Applet window. This means the panel can be positioned anywhere on screen.

The site itself offers a whole host of features. It is divided into four main sections: Music, News, Live and Tubescan. In this last section MTV is bringing the website more in line with a live television show. In the AMP section of Tubescan it is possible to download QuickTime movies of videos from the latest releases. Top 20 is updated every week: here the user can also download small QuickTime movies of the videos for each song.

There is an excellent animation section housing images, video and sound of all the MTV cartoon characters such as Beavis and Butthead. In fact if MTV gives any more away, it might have to start charging for it.

Creative director: Allie Eberhardt
Art director/senior graphic designer: Manabu Inad
Graphic designers: Vivian Kim and Kaeshi Chai

59

Tinseltown was created in 1996 by Seattle-based designer Ted Evans of Evans Peddle Gregutt (EPG). It was commissioned by *The Washington Post*, though unfortunately it never got past being a demo. Tinseltown breaks out of the constraints of a browser, taking up the whole screen. Had the site gone up on the internet, it would undoubtedly have caused a stir amongst the online community.

Although Evans never saw Tinseltown online, his Browser-free look was picked up by the Microsoft Network, for whom he is currently producing several shows. In terms of look and feel, once the browser has been done away with, the whole desktop is open to exploration. It is the possible near future of internet design. The site was going to act as a 'what's on and where to go in the city of Washington'.

The main interface placed the user in a lively urban neighbourhood from which five pathways could be accessed. The landscape depicted height and depth – the billboards and signage were designed on a human scale.

SuperCity

The hub of the Virtual World Wide Web.

The interconnected network of hundreds of 3D Web Pages.

Music: ON OFF

- News updated every week.
- World of the Week - Rabo Top 40.
- Full list of main 3D Pages - go to Index.
- Benefits of having your own 3D Page.
- How to get a 3D Page:-
 - Authoring Software.
 - Project Services.
- Free link to the WWW for your 3D Page.
- SuperCity and the Key Areas are supported and maintained by Superscape.
- Why not sponsor a key area?

Leading the race for cutting-edge 3D on the internet is Superscape with their impressive Viscape software. At the time of going to print the software was only available for PC platform, although a Mac version is promised very soon. Pictured above is the Hub, a rapidly growing series of interrelated virtual worlds.

From the virtual town centre the user can explore other neighbourhoods, all full of prime advertising sites. Superscape Viscape quickly computes the angles of your surroundings, which means the user can move more realistically within the space. It is a real architectural environment to explore.

At the moment the worlds lack the grit and grain the real world. However, the more advertising sol into these sites the better they will look. The Superscape Viscape plug-in can be downloaded from www.superscape.com

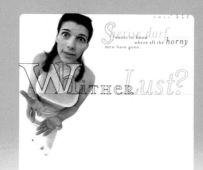

S *cerise dorf* wants to know where all the **horny** men have gone.

WITHER *Lust?*

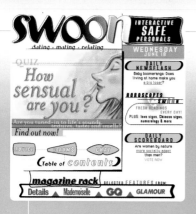

SWOON
dating · mating · relating

INTERACTIVE SAFE PERSONALS

WEDNESDAY JUNE 18

DAILY NEWSFLASH
Baby boomerangs: Does living at home make you a big loser?

HOROSCOPES SWOON
FRESH READINGS EVERY DAY!
PLUS: love signs, Chinese signs, numerology & more

DAILY SCOREBOARD
Are women by nature more socially adept than men?
VOTE NOW

QUIZ
How sensual are you?
Are you tuned-in to life's sounds, textures, tastes and smells?
Find out now!

ADVICE · FORUMS · CHAT

Table of contents

magazine rack SELECTED FEATURES FROM
Details · Mademoiselle · GQ · GLAMOUR

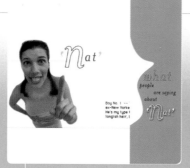

'*N*at'

what people are saying about '*N*at'

Boy No. 1 — ex-New Yorke
He's my type !
longish hair, l

One recent evening, I go out for drinks with a guy I recently met. He's five years younger than me, cute, funny. We finish our first cocktail, and he says out of the blue, "I have to level with you." (Yum. I love it when young guys talk about mature stuff like "leveling.")

epilogue

"What?" tee-hee flirt wi

"I want measly excitm

TABLE OF contents

WEDNESDAY, JUNE 18

FRESH TODAY

COLUMNS

FEATURES

SERVICES

MORE FEATURES

CHEAP date

american DREAMING
n o t h i n g
COULD BE FINER THAN TO BE IN ANDY GRIFFITH'S HOMETOWN, mount airy, n.c.

hot, cheap dates IN RALEIGH–DURHAM–CHAPEL HILL **plus!** THE triangle ON THE web

check out our other CHEAP DATES

New York

go!

I didn't move to Raleigh, N.C., to be closer to Jesse Helms and Tobaccoville, R.J. Reynolds' two-million-square-foot killing factory. I came for a better writing job. And not without some reservations, having called Boston my home for all of my 2⁶ years. But by mid-December, after I'd been here a month, I'd found there was plenty to do in Raleigh-Durham-Chapel Hill, called the Triangle because of how close the cities are to each other. We've got local bands (Archers of Loaf, Superchunk, the Connells, Southern Culture on the Skids), thrift shops, frat boys, $2 movie houses and transvestite bars. Fun for everyone!

Staying in the Northeast would have been easier. Just ask the thousands of other young writers so desperate to stay in the right place (Los Angeles, New York, Chicago, Boston) that they put up with supply name-droppers who front as editors and pay criminally low freelance rates (editor's note: This will be Geoff's last story for Swoon). In Raleigh, I spend $695 a month for a two-bedroom house with hardwood floors, a fireplace and a 30-foot front porch. Parking is free, the art theater is half of a mile away, as is work. It's all pretty sweet.

Anyway, Mount Airy is a two-and-a-half hour drive northwest of Raleigh, close to Virginia. I've never seen The Andy Griffith Show. The trendspotters, measuring cultural impact by what's on Nick-At-Nite, say it's an important marker of post-boomer America. Something about small-town life and post-War optimism and the irony of it all as we approach the millennium. A fine theory. Andy comes from Mount Airy, which is why, on the show, he and Don Knotts (Ralph Furley) lived in a town based on it. Only they called it Mayberry. Since I'd brought Carlene to North Carolina from Boston, it seemed appropriate to take her from the State Capitol to a place where people think Gomer Pyle really matters.

by GEOFF EDGERS

photographs by
SCOTT HEIDELBERG & JULIE OLMSTEAD/COLUMBUS COLLEGE OF ART & DESIGN

SCOREBOARD
JUNE 18, 1997

SIGN OF THE TIMES
Hoping to convince his wife to stop smoking, a Pennsylvania man simply asked her to kick the habit, albeit in a novel way. Morris Stahl, a resident of Swissvale, Pa., a Pittsburgh suburb, recently rented a billboard beside a busy road in his town, saying, "We love you Phyllis, please stop smoking." Stahl told Reuters that, in spite of the fact that she had heart surgery two years ago, his wife still smokes three packs a day. The sign, which hundreds of motorists pass daily, costs Stahl $300 a month.

If my lover tried to publicly humiliate me into dropping my favorite bad habit, I'd
○ quit the bad habit
○ quit my lover

I am
○ vice-ridden
○ relatively vice-free

VOTE NOW!

ARCHIVE FORUM

chat @ swoon

ATTENTION CHATTERS:
We're aware of continuing technical problems in our

Swoon

www.swoon.com

British webzine Swoon manages to be trashy, retro and camp. Produced by Condé Nast, purveyor of men's style bibles such as *Details* and *GQ*, Swoon bills itself as a magazine about dating, mating and relating. Its cool, fifties graphics ensure added kitsch and make a refreshing change from the rather flat graphics of the web. Swoon is an amalgam of all the trashiest contents a lifestyle magazine would carry. Seekers of 'love, friendship, hot times and witty self-actualized prose' may place personal ads on the site free of charge. No lifestyle magazine would be complete without a horoscopes section: these horoscopes make about as much sense as the ones found in any tabloid. The Daily Scoreboard allows readers to vote on an issue to do with relationships.

In short the contents of Swoon revolve around whose doing who.

Editor-in-chief: Lamar Graham
Senior editor: Jo Bargmann
Art director: Warren Corrbett
Swoon is a production of Condé Net, a division of Advance Publications Inc.

newsflash
wednesday june 18

SEXUAL ENLIGHTENMENT?

FEW ROMAN CATHOLIC PRIESTS have been openly in favor of the Church recognizing homosexuality for years, few other religious traditions have made a famous fuss over gay rights. That might be about to change, though. His Holiness the Dalai Lama, the exiled Tibetan Buddhist head of state and spiritual leader, met last week in San Francisco with gay and lesbian theologians to discuss homosexuality and Buddhism.

Urging respect, tolerance, compassion and the recognition of human rights for all, His Holiness voiced strong opposition to discrimination and violence against gay men and lesbians. But his support was not unequivocal; he mentioned traditional Buddhist teachings stipulating that oral sex, anal sex and masturbation generally constitute "sexual misconduct" -- even for married heterosexuals. "Even with your own wife, using one's mouth or the other hole is sexual misconduct," he told activists, according to the San Francisco Chronicle. "Using one's hand" -- that is sexual misconduct." While such regulations are hardly out of the ordinary in terms of world religions, they do place unreasonable limits on the modern gay lifestyle.

In any case, the Dalai Lama implied that further consideration of the issue might be in order. Buddhist sexual prohibitions "may be specific to a particular cultural and historical context," he said. (It is worth noting that Buddhism condemns sex with prostitutes.) However, he said that because he does not represent all Buddhists, he alone could not change the religion's teachings and that traditions other than Tibetan Buddhism should be consulted.

SEND THE NEWS TO A FRIEND

GO TO THE NEWSFLASH FORUM

VIEW PAST NEWS ITEMS

[FREE!] [ANONYMOUS!] [EASY!]

swoonomatic — THE SWOON PERSONALS

CREATE YOUR ALIAS	SEARCH THE PERSONALS
CREATE AN ANONYMOUS HANDLE FOR YOURSELF	SIMPLE SEARCH FOR THE BROADEST RESULTS. ADVANCED TO REFINE YOUR QUERY
POST A PERSONAL	REVISE/ DELETE
CREATE YOUR OWN PERSONAL ADVERTISEMENT	REVISE YOUR AD, E-MAIL ADDRESS, ALIAS, ETC.

EDITOR'S WEEKLY PICKS

WOMEN SEEKING MEN

MEN SEEKING WOMEN

WOMAN SEEKING WOMAN

MEN SEEKING MEN

OTHER PARTNERS, FETISHES, ETC.

CHAT SWOON

USERS' MANUAL

Welcome all seekers of love, friendship, hot times and witty self-actualized prose. Our personals are free, easy to use and completely anonymous. Just read our rules, and we'll help you locate someone who makes you swoon. There's also help if you need it.

Send your feedback to: personals@swoon.com. (We read everything, but sometimes the volume of mail prevents us from answering each individual message.)

HQ CONTENTS HOROSCOPES FORUMS SEARCH

by MELANIE MANNARINO

the PLUNGE

{scenes}

A weekly chronicle of MELANIE and JAMIE's (rocky, winding) road to connubial bliss

{tomorrow's bride}

Tomorrow's bride
Seating charts
High anxiety
Bands of gold
Sweating the details
The Shower
Nerves
The Dress
Rent-a-Priest
Planning
Telling the world
Engagement

Tomorrow's the big day and, as much as I hate to admit it, I'm not exactly in top form. The fraying began last Saturday night at my bachelorette party. It was pretty tame compared to the party Jamie's guy pals threw for him, which, of course, included strippers. The girls took me out for a big dinner and a little bar-hopping. OK, a lot of bar-hopping. All I can say -- after spending most of Sunday on the bathroom floor instead of at the U2 concert I had tickets for -- is that I will never again eat fried calamari and then do tequila shots.

But that alcohol-soaked nightmare is over, and I'm on to better things. The other day I called our catering liaison, a wonderfully comforting Martha Stewart look-alike, who promised that she would organize and orchestrate a walk-through rehearsal a few hours before the actual ceremony tomorrow. I also called the DJ, who said that, sadly, there will be no microphone available for possible readings during the ceremony. In other words, if someone is going to read, they better have a good set of pipes. I picked up my wedding gown and veil Thursday night and took it to the safety of my own home (I still hate the bridal boutique for keeping me waiting for so long). So, all that remains to be done is picking up my car from the shop, packing my bags for the honeymoon and getting lots of rest -- because I have just come down with a wicked sinus infection that has turned my nose a nice ruby red. (The consensus is that stress weakened my immune system, so I got sick. As if the explanation makes the situation any better.)

CHEAP DATE

[YOUR CITY] + YOUR SWEETIE + 20 BUCKS

swoon

MY LAZY SUNDAY WITH D-BOY

A FLEA MARKET, CRAPPY FOOD, A KISS... AS FAR AS DATES GO, THIS ONE WAS PRETTY LOW-KEY. UNTIL I RAN INTO MY EX.

LOW RENT ROMANCE **5** GREAT NY DATES

MANHATTAN SITE-SEEING **5** LINKS TO NY FUN

CHECK OUT OUR OTHER CHEAP DATES

New York

GO!

HOME CONTENTS HOROSCOPES FORUMS SEARCH MAGAZINE RACK PERSONALS CHAT

swoon

Seek...

What you'd like to find:

sticky toffee pudding [Search]

Looking for an A to a *Mademoiselle* Q? A juicy bit of bygo... Want to check if Celeste L. Smith's predictions from a few ... accurate? You've come to the right place. Just enter one or ... in the text box above, click the **Search** button, and you'll ... the Swoon items containing the word(s) you've searched fo...

For instance, if you enter **sex**, you'll call up items on every... transmitted diseases, to sex therapists, to good ol' s-e-x. ... search, use the words **and**, **or** and/or **not**. For example, to ... about sex, enter **sex and GQ**. Use parentheses to make yo... clearer: To find an article about sex in either *Details* or *G*... **and (GQ or Glamour)** Or to find every *Swoon* item abou... the daily features, try: **sex not (newsflash and scorebo**... **horoscope)**

We would say more, but we really don't have to. Searching ... more no less complicated than we've just explained. But if ... or comments, drop us a line: swoonfeedback@swoon.com.

61

TURNER CLASSIC MOVIES
'Director of the Month'
© 1994 Turner Entertainment
Designed and produced by RGA/LA

The main titles reflect title design and
animation from the Golden Age of film.
The beat and rhythm found in the
composition are inspired by 1950s
and 60s classic jazz album covers.

R/GA

www.rga.com

R. Greenberg Associates is a leading design
company in New York. Three different divisions
make up the group: R/GA Interactive, R. Greenberg
Associates and R/GA Print. Its homepage is an
example of just how well work can be shown online.
Written in Java (there is an older version for those
without a Java-enabled browser), the traditional
'click through pages' have been abandoned.

Navigation is via a grid of brightly coloured squares
in the same colours as R/GA's corporate identity.
Within the squares are photographs of pieces of
work completed by the company. Alternatively, if
you want to go straight to information about one
of the divisions, click on the appropriate square.
Once clicked on, the coloured square divides itself
into another grid and bursts out towards the user,
flashing the pieces of work you are about to see
until it finally settles.

Then users may view the offerings. Film is not
shown; instead there are plenty of frames to give
you an idea. There is plenty of text in each sectio
to explain the project. By colouring it and fitting i
to the grid using turn arrows, the words become
very effective, even on screen. Demos of CD-Rom
and internet work are available to download.

||| **1592** |||

[_2.5_] [_random_] [_search_] [_5.0_]

do it bigger + in one browzer

powered by bauer

Farmers' Manual

www.farmersmanual.co.at/fm

The Farmers' Manual is a site created for entertainment purposes by a group of artists living in Vienna who produce sound, video, graphics and online multimedia for experimental and commercial purposes. Also hosted by the Farmers' Manual is the Farmers' Subnet.

Here you may access //woeb.silverserver.co.at, an experimental web server running on a PPC 8100/100. The work shown is designed mainly by Sp, one of the Farmers. As a result the server contains mainly experimental graphics. It is also home to Red Tide Records, maintained by DJ Glow.

//ost.silverserver.co.at represents the lives of some of Vienna's musicians. //gert.silverserver.co.at is the homepage of Gert, the programming and coding Farmer. This site contains some cool scripts but less content. This is because it is a small server that he has running from his 7100/80 workstation.

 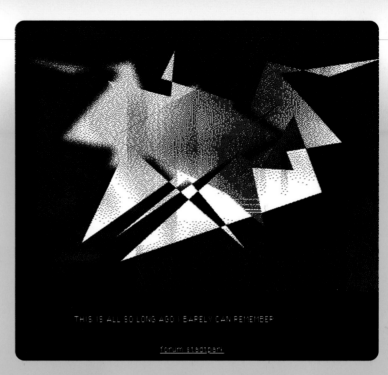

Fig. 1

Highway Six and www.interport.net/~xaf/,
18 miles west of the train tracks; blast3drama

The Interport is home to two new American media organizations, the X-Art Foundation and Blast. The X-Art Foundation is a non-profit-making organization that 'creates, encourages and presents new forms of arts and text. Engaging both traditional media and advanced technologies, it promotes a wide range of artistic practices, developing new combinations and perspectives for contemporary art and theory.' Multimedia artist Laurie Anderson was one of the founders of Blast, which was formed in 1990.

Blast set out to explore contemporary textual and visual information and their accompanying practices of reading, viewing and authoring. The projects of both these organizations can be viewed from the Interport.

If you are fanatical about anything, the internet is an excellent place to meet kindred spirits. Diehard fans of Batman and Superman should take time to check out the DC Comics website. The site cleverly fuses the entertainment of yesteryear with the technology of today.

As well as providing original artwork from the old comics, DC Comics can go further, for example, broadcasting the early Superman radio shows. Using RealAudio 2 you can listen to the original broadcasts (including the American public service announcements that were on before the shows).

The DC Comics site also offers bulletin boards for fans to chat and exchange ideas. It also makes its own Shockwave-powered comic 'webisodes'.

DC Comics is part of Warner Bros Online

Irn-Bru

www.irn-bru.co.uk/bigbrain.htm

Irn-Bru is Scotland's favourite soft drink. In the past couple of years it has tried to gain mass-market appeal by creating a youth-orientated advertising campaign exploiting the British sense of humour. Irn-Bru's website, created by Brand New Media, is an online extension of this campaign. It uses the same type and colours, yet it effectively changes the experience, taking it beyond print.

The homepage is a brain. Different parts of the brain contain the different sections of the site. The user is invited to click anywhere and explore. Each section of the site changes stylistically; clicking on Hols, for example, will bring up a campsite; click on the coach parked nearby and see the old dears looking out of the window. Underneath the image appear the lines to the song, 'If You're Happy and You Know it...' As the music begins to play, a small orange bubble will bounce over the lines.

There is much more entertainment of a similar nature to be gained from viewing Irn-Bru. There are also screensavers, desktop wallpaper and competitions. There is even a guided tour for those who cannot muster the energy to search the site – that really is something for the future.

1.4.1

These pages will talk if you are using Netscape 2.0, Apple's "English Text-to-Speech" software, and MVP Solution's "Talker" Netscape plug-in on a Macintosh computer.

To download the plug-in and more information visit the Talker web site.

???

Finally they are here – computers that talk. Jodi's Moobird site will speak to those who enter it through Apple's English Text To Speech. The computer Talker churns out loops of generated speech on any given subject, a frightening prospect for the future.

The Talker plug-in only works with Netscape on Macintosh computers. The download is a rather daunting 5MB. However, it is well worth the wait as there are Talker sites cropping up all over the internet.

These tell stories, act out plays, sing and generally entertain. A list of all the Talker sites and the plug-in is available at www.mvpsolutions.com/PlugInSite/Talker.html.

This innovative website belongs to a New York multimedia company of the same name. Zoecom is a collaboration of new media artists specializing in 3D environments and interfaces. Users may browse the portfolio (clients include Compaq and Altavista) or admire the VR work. The Zoetropes section shows off the talents of Zoecom's founder Till Krueger in QVR programming.

In the surreal Zoetropes world figures and shapes are animated using the same technique as flip book animation, only there are no pages. Instead the harder the user drags the images left, right, up or down, the faster the world spins round, creating the illusion of movement. Zoecom has also created complete virtual worlds which can be accessed from the site.

They require the browser Online! Traveler to view, which can be downloaded from Zoecom. There is also an excellent gallery space on Zoecom where artists of different disciplines exhibit their work.

Lite Board is an old web favourite from which a lot of valuable lessons can be learnt. The site dates back to May 1994 and is based on a seventies children's game, the object of which was to push coloured pegs into a plastic grid to make an image. Users may make their own masterpiece on the Editor page. There are five controls to aid creation.

'Pegs' allows the user to choose from one of seven different colours to put on the Lite Board grid. 'Views' displays the current picture being worked on. There is a Tools section to help edit the image, but users who prefer to use the keyboard can change the colours on the grid directly by using their Code option. Finally, once work is completed, the user may post their entry to the gallery.

As is the case with many simple, classic games – such as Pong and Space Invaders – the concept translates really well on the internet. The gallery itself makes great viewing. Some of the images posted are amazingly complex and have obviously taken hours to create. A site that commands the attention of its users to such a degree is definitely worth a visit.

69

Lite Board

//asylum.cid.com/lb

Spoken World

//spokenworld.msn.com

With the launch of Microsoft Network's Spoken World, storytelling on the internet has come into its own. Until now 'cyberfiction' has taken a text-based format, but no matter how engaging the tale, reading print on screen is a thankless task. MSN's Spoken World uses no on-screen text to deliver the story; instead its programs rely on a combination of images with a scripted audio dialogue.

The first online serial available is DreamSheet, created and designed by Los Angeles-based communications firm Frankfurt Balkind. Working in collaboration with Microsoft, DreamSheet will be a model for other online narratives on the Spoken World network.

DreamSheet is a non-linear experience. There are four characters in the story. Users can become a character or witness the story from anyone's point of view – there is a map which makes it easy to jump around to see exactly what any character is thinking. As sequences of images play out, the user is encouraged to 'screen scrub', that is, click areas of the photographs to check for hidden messages. An episode can easily last less than ten minutes.

CHOOSE A CHARACTER TO VIEW

TOM: VERONICA: AUSTIN BOYS: MORIARITY:

WEEK
WEEK
WEEK
WEEK
WEEK
WEEK
WEEK
WEEK

Dream Sheet Script - linear final draft 1.10.97.doc 36

Audio file: t06b01

Moriarity is laughing.

Then, the sound of a car starting. .

 ANGLE ON:

t6d EXT: RANCH - DAY

Audio file: t06b02

Moriarity's car, kicking up dust barreling towards
Moriarity.

 MORIARITY
 No. It can't be. Son of a
 bitch.

A thump as the car pops him. The car stops.

 ANGLE ON:

t6e EXT: RANCH - DAY

Bernard behind the wheel of the car, holding his Rubik's
cube. Moriarity's nice cowboy boots in the dust.

Audio file: t06b03

The car's shutting off with a sputter.

 BERNARD
 I hated what he did.

 VERONICA
 So it was you all along.

 BERNARD
 Yes.

 VERONICA
 What about the rest of it?
 BERNARD
 (Laughs.)
 CUT TO:

t6f EXT: RANCH - DAY

TOM/VERONICA/MORIARITY
Episode Six
Scene Two

TRIGGER HOT SPOT

BOOT HOT SPOT

70

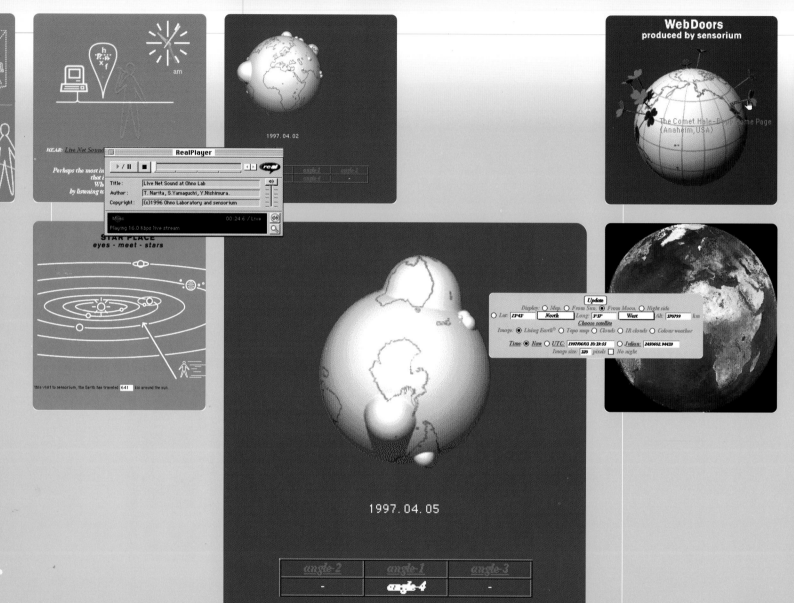

BREATHING EARTH
network - senses - living planet

1997.04.05

1997.04.02

WebDoors
produced by sensorium

The Comet Hale-Bopp Home Page
(Anaheim, USA)

am

HEAR: Live Net Sound

STAR PLACE
eyes - meet - stars

this visit to sensorium, the Earth has traveled 641 km around the sun.

RealPlayer

Title : Live Net Sound at Ohno Lab
Author : T. Narita, S.Yamaguchi, Y.Nishimura.
Copyright : (c)1996 Ohno Laboratory and sensorium

Mono 00:24:6 / Live
Playing 16.0 Kbps live stream

angle-1 angle-2
angle-4 -

1997.04.05

angle-2 angle-1 angle-3
- angle-4 -

Update

Display: ○ Map ○ From Sun ● From Moon ○ Night side
○ Lat: 17°45' North Long: 9°37' West Alt: 376799 km
Choose satellite
Image: ● Living Earth ○ Topo map ○ Clouds ○ IR clouds ○ Colour weather
Time: ● Now ○ UTC: 1997/06/03 16:39:55 ○ Julian 2450602.94439
Image size: 320 pixels □ No night

Sensorium

//amsterdam.park.org:8888/Japan/Theme

Sensorium is a website that seeks to allow the user the ability to sense the world in different ways. 'Humans are currently in the process of creating a new world and society in another dimension. In the form of new networks connected via the internet.' Sensorium was launched on the internet at the Internet 1996 World Exposition.

The project's producer is Shin'ichi Take Mura of Project Taos. Project Taos is a group of professionals led by Shin' ichi who is an anthropologist and associate professor at Tohoku University of Art and Design. The site takes in different forms of data and transforms them on the internet. The Webhopper section gives a graphical depiction of the physical location of people on the internet around the world.

The Netsound section turns the noise of the networking system in the Institute of Technology Tokyo, into music. In Breathing Earth (illustrated above), all the earthquakes that have taken place in the last two weeks are shown on a globe.

WebDoors
produced by sensorium

SFC Mt Fuji Server/富士山サーバー
(Fujisawa, Japan)

次に火之夜藝速男神を生みき。
亦の名は火之炫毘古神と謂ひ、
亦の名は火之迦具土神と謂ふ。
この子を生みしによりて、
みほとを炙かえて病み臥せり。
たぐりに生れる神の名は、
金山毘古神。次に金山毘賣神。
次に屎に成れる神の名は、
波邇夜須毘古神、次に波邇夜須毘賣神。
次に尿に成れる神の名は、
彌都波能賣神、次に和久産巣日神。
この神の子は、豊宇氣毘賣神と謂ふ。
故、伊邪那美神は、
火の神を生みしによりて、
遂に神避り坐しき。

Kojiki ("The Records of Ancient Matters," 712),
Japan's oldest book,
tells us that

Izanami, the Goddess of Creation,
gave birth to a number of deities
before finally giving birth to the God of Fire,
as a result of which her genitals were burnt
and she became bedridden.
In her illness, she gave birth some last few times,
and then expired and migrated to the Land of the Dead.
While on her sick bed, she vomited,
and from her vomit was born the God of Mining;
she excreted, and from her feces the God of Clay was born.
From her urine was born the God of Water for Irrigation,
and then came the young and virile God of Procreative Force
followed by the Goddess of Food.
And then came the God of Fire.

WebDoors
produced by sensorium

Mawson Station, Antarctic
(Tasmania, Australia)

IWE'96 Japan/"sensorium"

sensing Japan

What does "sensing Japan" mean?

Masanobu Shibuya @Kushiro
Shibuya Dived in the Icy Swamp, March 1996

Takeshi Mizukoshi @Mt Fuji
Mizukoshi Shot Fiery Mountain, April 1996

Tsuruhiko Kiuchi @ Nagano
Living with Comets, July 1996

sensing Japan Opening Special: Kobe One Year After

Takashi Tsumura @KOBE
Tsumura Interview on the Quake's Aftermath: Part 1, January 1996

Mariyo Yagi @KOBE
A Living Rope That Connects Us All, January 1996

Masanobu Shibuya @KOBE
A View of Kobe from the Sea, January 1996

Takashi Tsumura @Kobe
Tsumura Interview on the Quake's Aftermath: Part 2, March 1996

Takeshi Mizukoshi @ Yakushima Island
Mizukoshi Shot Subtropical Winter, February 1996

Yoshihiro Kawasaki @Yakushima Island
Kawasaki Felt the Island's Pulsating Life-Force, May 1996

Mawson Friday, 23 June 1995 1:00:05 PM

Temperature deg C

Wind Speed (knots) or 3 km/hr

Direction the wind is blowing to (deg)

Wind Chill : -16 deg C
Sensation : Bitterly cold

View information about the we

Live pictures from Mawson Sta

What life at Mawson is like.(we

Mawson Station and Horsesh

Shag

www.sirius.com/~shag/index2.html

Shag is a two-person company based in San Francisco. In their time Lizard and Terbo, aka Shag, have made furniture, graphics, video, music, clothing and software. Their experience is bundled together to create a website which is like nothing on earth. The Shag homepage provides the user with a whole host of choices, places to visit and games to play. They have created most of these sites themselves.

The Shag site combines bright images, animation and sound. The way Shag combines the three, though humorous and anarchic, puts this site at the cutting edge. Strongly recommended is The Terbo Shag Comic, a regularly updated comic strip entitled 'Adventures In The Plasma Field'; The Midi Wall, a whole page of sound files; and 'Some Other House', a stop motion animated series.

Because this animation technique is seen as rathe old-fashioned, the guys at Shag have added a nic touch – the pages are in black and white, somethir you do not really see on the internet. One thing to be sure not to miss is Terbo Ted's Death Patrol.

Ja

!!

st

aScript Alert:

Sorry, this page i

under contructi

The inherent strength of the internet – its very reason for being – is its ability to transfer information from one computer to another. There is a body of opinion which proposes that anything that gets in the way of such transfers is limiting the ability of the net to do what it is best at. Time spent waiting for fancy graphics to appear is time that could be spent garnering information.

We have devoted many pages to exhibiting just how much exciting visual content there is out in cyberspace in a bid to convince the sceptical that the web offers visually creative opportunities. Despite the limitations of bandwidth and screen resolution it is possible to produce arresting imagery for the web. But we also recognize that some of the most interesting websites scarcely appear to have been 'designed' at all in a visual sense. Their strength lies beneath the surface – not in graphic design but in information design or in the architecture of the site itself.

Some sites that appear to be almost entirely text-based make great strides in defining what it is that the internet is best at and in illustrating what makes it unique. Amazon.com is billed as the world's largest book store. There are two and a half million titles available, 24 hours a day. About a million of these are out of print. A dedicated search engine allows users to find books by genre or by key word, by title, author or subject. The results provide the publication date of a title, its dimensions, ISBN and shipping details – even reviews and comments from the author. Purchases can be packaged, even gift-wrapped, and shipped anywhere in the world.

The site may not look like much but Amazon.com functions superbly.

If you want to buy something other than books, Digicash has links to hundreds of online shopping services. Digicash is the organization that created the software for the electronic money which makes net transactions possible. Its site details stores for

us that good design improves understanding and facilitates access to information. There is no reason why the same principles should not be applied to the internet.

Other sites perform useful functions in cyber-society, yet their lack of visual impact may lose them viewers. Digifest provides a directory of free-to-use sound files, while Bigfoot is a directory of email addresses with around 8 million to search from. Members are provided with a free email address for life and customized email services.

It is a very useful resource and, through its email filtering service, it also addresses a growing problem on the net – spamming. Just as householders get annoyed at the avalanche of unsolicited mail which arrives on their doorstep each day, so internet users are aggravated by its electronic equivalent. Spamming is the distribution of digital junk mail.

Each time someone surfs the net they leave a trail, a digital fingerprint which reveals where they come from, what kind of computer they have and what software it is running. Most sites keep a log of visits. The more sophisticated ones keep a record of what each visitor does once they are there, building up a picture of their interests. To marketing departments, this is highly valuable information allowing companies to build up sophisticated consumer profiles. It can also be sold on to other companies for spamming.

A site called Anonymizer allows people to surf the web without leaving any traces. It acts as a middle man between the user and the sites they wish to view. Users prefix the site address they need with the URL of the Anonymizer server which finds the information and sends it on to the user.

Thus, Anonymizer is one of the most innovative and useful sites on the web, but visually it is at best unexciting. This may not matter to everybody but there are many casual surfers out there who are seduced first and foremost by eye candy. If they alight on a site which requires lots of (heaven

the net. It is a spoof hacking organization offering an authentic-looking Internet Shoplifting Service which will steal either products or information and deliver to your door. Its creators claim it is 'our twisted attempt to poke fun at the vulnerability that our society suffers from as we move into the information age. On the other hand it is not a joke in the sense that the future of our society depends on the ability to protect information. That is what we are working on in real life.'

Digicrime makes a contribution to the culture of the internet but it is a contribution that many visually-led users will miss because it is not presented in a way that excites them. Not all internet users are design-conscious by any means, but evidence suggests that images rather than text are the way forward for the presentation of information on the web. Text on a screen is difficult to read and dull to look at. Arguably, anything over a few hundred words belongs on the printed page.

The innovative use of imagery and sound can build the web into a truly unique medium. The challenge for designers is to keep out of the way of what the net is good at. To help, not hinder, and to bring out its strengths. To harness the power of a site like Amazon and marry it to the visual appeal and aesthetic pleasure of shopping in the finest of retail outlets. It is up to designers to ensure that websites can be both visually and intellectually stimulating, not either or.

Check out the following sites:

www.amazon.com
www.digicash.com
www.digifest.com
www.bigfoot.com
www.anonymizer.com
www.digicrime.com
www.digicult.org
www.well.org
www.superscape.com

o

Contributors

Andy Cameron, Ted Evans, Jayne Loader, Jake Tilson, David Karam, Gigi Biederman, David Colleen, Tom Bland, Tom Butcher, Ofer Cohen, Michael French, Michael Williams, Gareth Ingram, Yannis Marcou, Zak Ezzati, Brett Wickens, Stefan Prossert, Dextro, Dirk Paesmans, Ammon Haggerty, Joan Heemskerk, Heath Bunting, Jordon Crandall, Justin Vir, Pamela Kerwin, David Redhill, Brad Johnson, Michael Samyn, Roger Black, Global Café